# TRADITIONS
# *Transfigured:*
## THE NOH MASKS OF BIDOU YAMAGUCHI

Edited by Kendall H. Brown

**With essays by**
Kendall H. Brown

J. Thomas Rimer

William T. Vollmann

Matthew Welch

**Catalogue entries by**
Anne Geismann Alene

Kendall H. Brown

David De Boer

B. Karenina Karyadi

Sheida Koufigar

Lauren Nochella

Kristy Odett

Ariana Rizo

Mary Grace Sanchez

Gail Schlicht

University Art Museum
California State University, Long Beach

Distributed by University of Washington Press

This volume is published in conjunction with the exhibition *Traditions Transfigured: The Noh Masks of Bidou Yamaguchi,* organized by the University Art Museum at California State University, Long Beach, from January 25 to April 13, 2014.

The exhibition and catalogue were made possible by the McLeod Family Foundation and were supported by IRA and ASI grants from CSULB.

University Art Museum
CSULB College of the Arts
1250 Bellflower Boulevard
Long Beach, CA 90840-0004
csulb.edu/uam

Front cover: Bidou Yamaguchi, *Mona Lisa* [cat. 11];
back cover: Bidou Yamaguchi, *Zō-onna* [cat. 10].

ISBN
978-0-615-87883-6

Library of Congress Control Number: 2013953736

# Contents

# Director's Preface and Acknowledgments

For over forty years, the University Art Museum has served as a leading voice within a forward-thinking academic community by presenting exhibitions and programs that explore a wide range of ideas. The museum has also offered artists a place to experiment and present new work while maintaining a strong commitment to scholarly and curatorial excellence. As such, the museum enjoys the respect of both regional and national audiences. *Traditions Transfigured: The Noh Masks of Bidou Yamaguchi,* organized by Dr. Kendall H. Brown and students from the Museum Studies program, continues this trajectory.

Bidou Yamaguchi is an emerging Japanese artist who reinterprets his country's tradition of Noh mask carving for a contemporary audience. Noh masks were first developed during the Muromachi period as an integral component of Noh theater, and their often seemingly neutral expressions belie the great range of emotions created when masks are activated by skillful actors. This rich heritage had changed little since the fourteenth century until Bidou reinterpreted it through the lens of iconic western portraiture. In *Traditions Transfigured*, the artist's first West Coast museum exhibition, the poetics of the East meet the lyricism of the West. It is our hope that this exhibition will advance Bidou's distinctive contribution to the field of contemporary art.

The exhibition could not have taken place without the assistance and concerted efforts of many people. We are indebted to Dr. Brown, who conceived this project and was responsible for all aspects of the exhibition and this publication. Under Dr. Brown's tutelage, Museum Studies students B. Karenina Karyadi, Lauren Nochella, Kristy Odett, and Ariana Rizo contributed to the curatorial process at every step and worked seamlessly with the University Art Museum staff to realize this challenging exhibition. This exhibition and catalogue would not exist without Yoshida Ayomi's generosity of time and spirit. In addition, museum staff members Ilee Kaplan, Kristina Newhouse, Brian Trimble, Angela Barker, Pet Sourinthone, John Ciulik, and Shirley Brilliant have worked diligently to coordinate the exhibition's production, including shipping, installation, and educational programs. Many thanks are due to Christopher Miles, Dean, College of the Arts, and Donald Para, CSULB President, for their continued commitment and ongoing support of the museum and its programs.

My sincere thanks and appreciation extend to the following private and institutional lenders, many of whom devoted considerable time and energy to ensure that important works were available for this exhibition: Kelly Sutherlin McLeod and Steve McLeod; Sebastian Izzard; Hollis Goodall, Los Angeles County Museum of Art; Bridget Bray and Annie Kuang, USC Pacific Asia Museum; Mary MacNaughton and Kirk Delman, Ruth Chandler Williamson Gallery, Scripps College; Amy Kuelz, Target Corporation; Michael J. Lyons, Ritsumeikan University, Kyoto; Kitazawa Hideta and Jubilith Moore, Theatre of Yugen, San Francisco; Morimura Yasumasa; and Odani Motohiko.

Catalogue essayists J. Thomas Rimer, William T. Vollmann, and Matthew Welch contributed fresh and even radical perspectives on Bidou's artistic practice. The publication was enhanced by catalogue entries written by Museum Studies students Anne Geismann Alene, David De Boer, B. Karenina Karyadi, Sheida Koufigar, Lauren Nochella, Kristy Odett, Ariana Rizo, Mary Grace Sanchez, and Gail Schlicht. I am extremely grateful to Kuniko Brown, for help with translation, and to Margaret Black, for designing such a stunning volume. Jean Patterson edited the catalogue thoughtfully and insightfully, while Suemasa Mareo in Tokyo and Rebecca Sittler in Long Beach contributed beautiful photographs of Bidou's work.

On behalf of the University Art Museum, I would like to thank the McLeod Family Foundation for its very generous donation; we are also grateful for grants from Instructionally Related Activities and Associated Students, Inc., for financial support of *Traditions Transfigured.*

Finally, this project would not have moved forward without the consent and blessing of the artist himself. At every stage of the project, Bidou Yamaguchi has been collaborative, gracious, and supportive.

Christopher Scoates
Director, UAM, CSULB

# ESSAYS
---

Kendall H. Brown

J. Thomas Rimer

William T. Vollmann

# MASQUERADE: THE REVELATORY ART OF BIDOU YAMAGUCHI

Kendall H. Brown

### 1. INTRODUCTION

Like a human face, the work of Bidou Yamaguchi opens itself to many angles of interpretation. The product of a Noh mask carver who also creates modern sculpture in the form of masks, Bidou's central creations are iconic female images from European painting and Japanese *ukiyo-e* prints. His art speaks to such issues as cultural identity, gender, portraiture, performance, representation, simulacrum, appropriation, and transgression, as well as the roles of beauty and craft in contemporary art. The essays in this catalogue do not address all of these concerns, and rarely do they seek to reveal the artist's intentions.[1] These texts are meant to stand alongside Bidou Yamaguchi's art, which is presented here in photographs that themselves are representations and interpretations. Like the accompanying images, each text captures the distinct viewpoint of its author. While the photographs inevitably flatten the sculptures, making them look more like the well-known paintings and prints from which they derive, the essays seek to push the work in new directions, making it more "three dimensional."

Fig. 1

Portrait of
Bidou Yamaguchi

Our fundamental premise is that Bidou's art is informed by the world of Noh, and, in turn, offers insight into this diversely creative realm of theater and image making. We stress the productive links between Bidou's roles as a "traditional" artisan who works to reproduce old masks and as a contemporary artist who makes new objects. We treat these fresh creations as "masks," although they were not commissioned for use in Noh plays. In fact, the oblique orientation of the eyes in most of these portraits differentiates them from Noh masks. Despite these differences, our approach imagines these works as potential characters in future dramas.

The exhibition is divided into three parts, mimicking the tripartite *jo* (stately introduction), *ha* (quickening development/break), and *kyū* (fast finale) structure used in a single Noh play and in a program of plays. It begins with an introduction to Noh, using Bidou's "reproduction masks" made for contemporary actors and woodblock prints by the great artist of Noh, Tsukioka Kōgyo (1869–1927). In the catalogue, J. Thomas Rimer's essay, "Noh as Total Theater," outlines the history and structure of Noh.

The climactic middle, or *ha* section, presents Bidou's uncanny masks that transfigure familiar portraits. It is divided into three subsections: the *European Painting* series, the *Ukiyo-e* series, and *Angelina*, from a nascent series of living persons. The catalogue, by contrast, concentrates on the aesthetic strategies and affective resonances of the *European Painting* series. In Noh, so-called woman plays *(onna mono)* are included in the *ha* category. Because these plays involve transgression against the natural order and feature ghosts who occupy temporary identities, the radical temporal, cultural, and spatial breaks that define Bidou's female portraits are well suited to a *ha* sensibility. William T. Vollmann's essay, "Made to be Ambiguous," muses on the quality of *yūgen* (subtle profundity) in Bidou's *Mona Lisa*, and brief entries explore the thematic and formal connections between Noh and these nine portraits of iconic women, and a mask that imagines Angelina Jolie as a new kind of character fit for Noh.

The exhibition's conclusion explores three aspects of the dynamism of masks: their process of creation, the way in which some female masks shift their expression based on pivoting upward (*terasu,* "shining") or downward (*komorasu,* "shading"), and the sense of transformation attendant upon donning a mask. The catalogue abjures these components more appropriate for museum display. Instead, because a play's *kyū* section involves resolution and reintegration, the catalogue concludes with the essay "Tradition Transfused," on Bidou's *Ukiyo-e* series, in which Bidou returns to Japanese theatrical subjects, fusing plebian Kabuki and aristocratic Noh. Written by Matthew Welch, who commissioned some of this work for the exhibition *Edo Pop*, the essay links Japanese prints of the Edo period (1615–1868) and contemporary creations.[2]

This essay, a kind of curator-narrator's prologue, first provides a basic biographical sketch of the artist, which is deepened and broadened in Welch's concluding text. This introduction then outlines some ideas about craft and art that seem germane to work produced within the Noh ethos. Next it analyzes Bidou's work in relation to shifting western and Japanese practices of appropriation and portraiture. It contextualizes Bidou's work among other recent art that deploys the image or form of a Noh mask, and it seeks deeper resonances between Bidou's work and Noh practices and sensibilities—with the critical idea of *yūgen* deferred to Vollmann's essay.

## 2. Noh Mask Maker, Artist

Bidou Yamaguchi's art evokes fresh vision by calling upon the past. Although the artist is the graduate of a modern art school, his work is informed by the apprentice system that has nourished Japanese art for generations. Born Yamaguchi Hiroki in 1970 in the city of Fukuoka, he studied at Kuwasawa Design School in Tokyo. Yamaguchi took classes in many areas, including three-dimensional sculpture, but he majored in graphic design, having been impressed with the modern sensibility yet Japanese taste of the famous

graphic designer Tanaka Ikkō (1930–2002). After graduating in 1991, Yamaguchi went to work for a design company, where, despite the stream of work produced by Japan's "bubble economy," he became disheartened. The ephemeral life of his commercial designs bore little relationship to the passion and thought invested in them.

Before starting work, Yamaguchi had traveled for three months in the United States. Moved by the Japanese art carefully displayed in American museums, on his return home Yamaguchi

Fig. 2

Bidou Yamaguchi
*Celestina*, 2011
Japanese cypress, seashell,
natural pigment, lacquer
7.87 x 5.28 x 2.59 in.

began to search for a fulfilling type of expression in Japanese idiom. In this journey he was impacted by Yoshida Ayomi (b. 1958), his traveling companion and, later, his wife. Yoshida had wrestled with the idea of innovating the woodblock print form, eventually producing installations that incorporated wood chips and blocks in addition to prints.[3]

One day in 1992, Yamaguchi awoke to a vision of himself as a maker of Noh masks (*nōmenshi*). Receiving support from Yoshida, he began to look for a teacher. When no teacher would take on this unorthodox pupil, Yamaguchi began to teach himself. A toolmaker, consulted about proper tools, introduced Yamaguchi to one of his other clients, the Noh mask maker Ogawa Gendou (b. 1945).[4] On seeing Yamaguchi's self-taught work, Gendou took on the talented beginner. Just four years later, in 1996, to mark the student's graduation to rank of master, Gendou bestowed on his student the art name Bidō 毘堂 [fig. 1]. Writing the name in Latin letters for an international audience, the artist altered the spelling to "Bidou" and reversed the order of his family and art names to become Bidou Yamaguchi. (That name order is used here, even though other Japanese names and words are given in Japanese order and standard orthography—with the exception of the familiar "Noh.")

In 1998, Hōshō Fusateru (1958–2010), the nineteenth head of the Hōshō school of Noh, granted Bidou status as a purveyor of masks to the Hōshō school for use by their actors. With this stature and encouragement, Bidou also began creating masks for museums that would display rather than use them. Traveling to America and Europe with his wife, whose career was evolving quickly, Bidou lectured on Noh mask creation at museums and art schools. In June 2006, the Asian Art Museum of San Francisco invited him for a month-long residency as part of its AsiaAlive program, featuring

demonstrations by Asian artists who maintain older art forms. Although Bidou had already begun producing "new" work translating European paintings to Noh mask form, museum administrators viewed him as a traditional artisan rather than as a contemporary artist.

Such distinctions have a bureaucratic logic but miss a core element of Bidou's work. Bidou uses the term *utsushi* (reproduction) to refer both to his copies of old masks and to his adaptations of old paintings into mask form. Although one kind of work reproduces an existing form, and the other translates two-dimensional renderings of actual people back into three dimensions, both necessitate physical understanding of the earlier object, working out the approach of its maker, and even imagining the character of the human subject portrayed. During his training, Bidou and his teacher discussed how the neutral or indeterminate expression *(chūkan hyōjō)* of Noh masks of younger women like Ko-Omote and Zō-Onna [cat. 10] recalls the beguiling smile of Leonardo's *Mona Lisa,* and how the Noh mask maker, like the brilliant portrait painter, is challenged to capture such nuance.

Frustrated with the prospect of spending his career repairing or faithfully reproducing old masks in a tradition that brooks no innovation,[5] in 2003 Bidou became a heretic. His heresy was *Mona Lisa* [cat. 11], a transformation of the western icon, not as a parody but rather through the transfiguration of the familiar face into the unfamiliar form of a Noh mask. Despite the unprecedented subject, in the work Bidou maintained his identity as a *nōmenshi* by deploying only the materials, tools, and techniques used for Noh masks. His *Mona Lisa*—and the subsequent works that engage human faces—retains the ear holes (used to affix the cord by which actors wear or "hang" a mask) and eyeholes (through which a hypothetical actor would gaze) of a functional mask. Yet, because no theatrical use was intended and, in later examples, the eyes gaze obliquely rather than frontally, as in Noh masks, Bidou regarded the work as art sculpture *(chōkoku)*. Yet, the potential theatrical function of an art object that retains the physical form of a mask locates Bidou's work in the realms of both Noh and fine art—a distinction already bridged in part by the placement in Japan of Noh masks (along with Buddhist ritual implements and samurai swords) in art museums. Bidou's work and, more broadly, his career(s) as "artisan" and "artist," signals the contingent definitions that have swirled around object making in Japan for the past 150 years.

Between 2003 and 2007, Bidou made eight more works in what would become the *European Painting* (or *European Portraits*) series [cats. 12–19]. Each mask, materializing the face of an iconic woman from European art history, is based on an image studied from a photo reproduction. In the earliest works, Bidou was fascinated not merely with returning these women to the corporeal realm but also with replicating the effects of oil and tempera paint in Japanese mineral pigments. Further, in order to capture the effects of age and damage much prized in *utsushi* masks of the Hōshō school, rendering the crazing or crackling on Old Master oils offered a new challenge. After mastering these techniques and exploring how the naturalistic physiognomies of Renaissance portraits fit aspects of Noh mask form, Bidou investigated the expressive modes and effects used by such painters as Munch and Modigliani.

While these subjects all share a compelling beauty, and perhaps even a function as muses, in 2011 Bidou inflected the series with a work that abjures canons of female beauty and notions of positive inspiration. In *Celestine* [fig. 2], Bidou takes on Picasso's 1904 Blue Period portrait of a blind, witchlike panderer. This macabre visage suggests Bidou's first exploration of a European equivalent to Noh's many demonic figures and may well prefigure a new direction for his art.

Bidou's finished works convey a kind of perfection that belies his creative choices and the experiences that inform them. When considering making another human visage from Leonardo's *Lady with an Ermine,* Bidou became fascinated with the animal instead and turned it into the masklike sculpture *Ermine* [fig. 3]. By exploring the potential of an animal's face to convey vitality and even character (reportedly Leonardo found the animal a symbol of purity), Bidou implicitly connects humans and animals. The Buddhist worldview implied in such thinking is underscored in Bidou's *Gibbon* [fig. 4], based on the triptych *Guanyin, Gibbons, Crane* by Muqi (c. 1210–c. 1269), owned by the Zen temple Daitokuji. Not only has the painting long been treasured in Japan as an icon in the transmission of Chan/Zen culture, but the gibbon was also frequently appropriated by the painter Hasegawa Tōhaku (1539–1610). For Bidou, rendering the variety of brushstroke types used in ink painting *(suibokuga)* provided a technical challenge and signaled a desire to find an East Asian equivalent both for European oil painting and for psychological portraiture.[6]

In 2008 and 2009, Bidou stopped representing human faces and turned to animals. In those years Bidou made monthly visits to Fukuoka to see his father, who was seriously ill. Contemplating his father's impending death, Bidou felt unable to create human faces. With their relatively short lives and the threat of extinction for some species, animals constituted a different but, in some ways, more immediate, problem of existence. His *Endangered Animals* series includes the heads of a Japanese wolf [fig. 5], polar bear, American eagle, chimpanzee, and leopard. Although the Japanese wolf adapts the mask form, the other sculptures do not. Because these works are not displayed on the artist's website or in his gallery shows, it seems that Bidou has distanced himself from the work, either because of its difference from his usual "masks," or because of the recollection of a painful time in his life. Nonetheless, these animals reveal his probing of new subjects and themes.

Around the same time that he was appropriating Muqi's *Gibbon,* Bidou started to explore culturally based ideas of representation and identity as expressed in the practice of portraiture. In 2007 he made the "mask" *Onayo* [cat. 22], based on the woodblock print *Sanogawa Ichimatsu III as Onayo, the Prostitute of Gion* [cat. 21] by Sharaku (fl. 1784–95). Not only is Sharaku one of Japan's best-known and most mysterious artists, but, according to one theory, he was the Noh actor Saitō Jūrōbe.[7] Sharaku's idiosyncratic

Fig. 5

Bidou Yamaguchi

*Makami* (Japanese Wolf), 2009

Japanese cypress, gesso, graphite, metal, lacquer

7.68 x 5.83 x 5.39 in.

Fig. 3

Bidou Yamaguchi

*Ermine,* 2007

Japanese cypress, seashell, natural pigment, lacquer

4.13 x 4.33 x 3.31 in.

Fig. 4

Bidou Yamaguchi

*Gibbon,* 2006

Japanese cypress, seashell, natural pigment, lacquer

5.31 x 5.59 x 2.17 in.

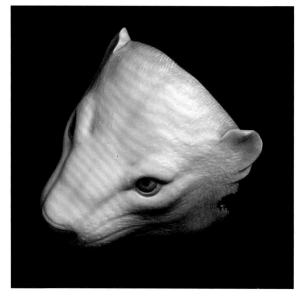

Fig. 3

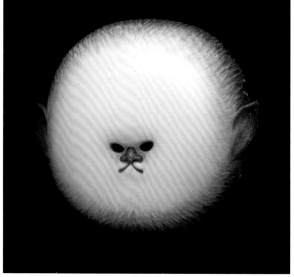

Fig. 4

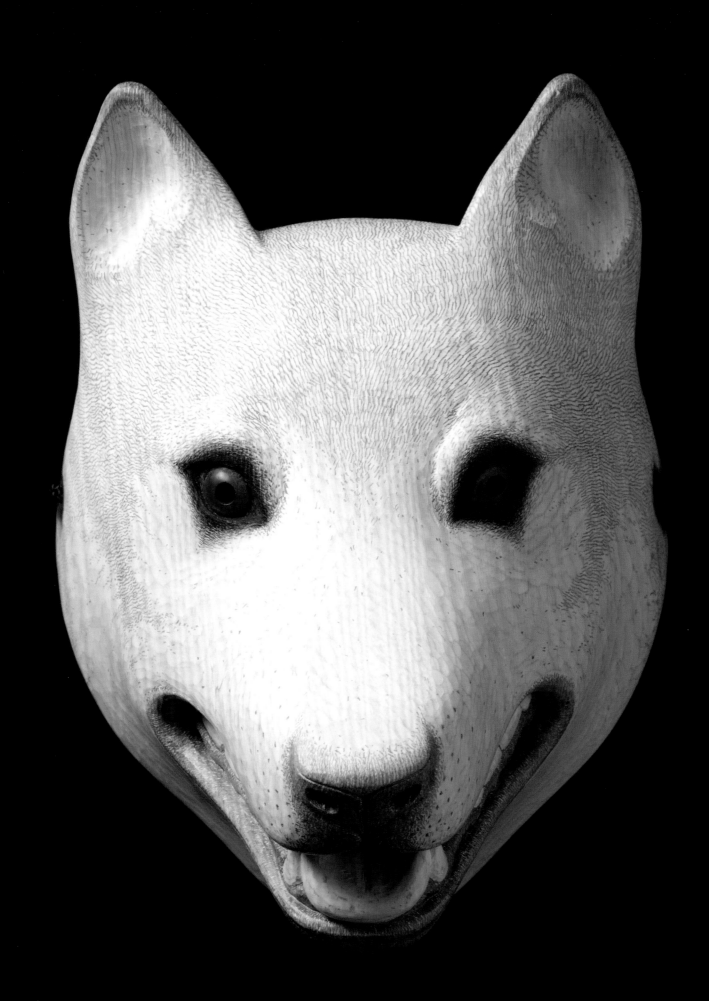

emphasis on the individual appearance of the actor in the assumption of a role has led some art historians to posit him as the Japanese equivalent to Europe's best portraitists. Matthew Welch's essay explores the first works of Bidou's *Ukiyo-e* series, which has continued with four new masks made in 2012–13 from prints by Sharaku and Kitagawa Utamaro (c. 1753–1806), on commission from Sebastian Izzard, a dealer of Japanese art. Throughout these varied explorations of subject and theme, Bidou maintains a meticulous commitment to technical skill.

### 3. Crafts and Arts

In making Noh masks and masklike sculptures, Bidou has mastered three distinct practices: carving, painting, and aging (the distressing required to give the appearance of decay). The laborious handmade production and potential utility of his new work, along with Bidou's status as a Noh mask "craftsman," raise issues of definition and status: are these works fine art or high-end craft? Since the eighteenth century in the West, and the late nineteenth century in Japan, fine art and industrial art (or craft) have been positioned in a tense binary relationship.[8] The standard assumption is that, in an age that equates art with the expression of ideas to the degree of championing pure concept, works that display copious amounts of skill and investment of time risk being devalued as "mere craft." Bidou belongs to that set of modern artists whose work reveals the reductive limitation of such zero-sum thinking. Instead, Bidou's work embraces a definition of art as born in part from technical mastery. It also underscores a notion of creativity as an incremental process of learning from the ancients and from one's experience, rather than as a conceptual or even physical act performed *ex nihilo* and *de novo*.[9]

Technique and process, in this view, are not merely a means to an end; they are the equal of the concept in the realization of the finished object. As such, they constitute a kind of artistic thinking and help make up the "intelligent effort" that produces quality, in the famous formulation of the English writer and critic John Ruskin (1819–1900).[10] Wood carver and Yeats scholar David Esterly has written about how the process of making changes the artist, humbles him or her, and thus effectuates its own end. In this view of art as a process and a product, the more complex and engaging the method of creation, the greater the depth of the finished object for the artist and for the engaged viewer. As Esterly writes, "The *work* of art and the work of art transport you to the same charmed place."[11]

All of Bidou's sculptural art follows the techniques used for making Noh masks. The woodworking begins with the selection of aged cypress and moves from cutting the wood with saws, to rough carving (*arabori*) of the basic shape with a mallet and special chisels [fig. 6]. The modeling (*nakabori*) of the face proceeds from front and back with curved chisels and gouges. The finished carving (*shiagebori*) brings out the facial features, then smoothes the surface using fine chisels, never sandpaper. Holes, in the rough position of ears and used to tie on the mask, are created with heated iron pokers. The rear of the mask is lacquered and signed by the maker. Then the front is brushed with several undercoats of baked, ground seashell (*gofun*) and animal glue (*nikawa*). When dry, it is burnished with the leaves of various plants. In the painting stage (*shiagenuri*), Bidou uses fine brushes to apply mineral pigments (*ganryō*), then *sumi* ink to paint the hair. The final technique, kept secret, is the patination or aging (*koshoku-zuke*) to reproduce damage and wear.[12] For *Mona Lisa* and similar works, Bidou used his finest chisel to carve the delicate network of cracks in the varnish. In his *Ukiyo-e* series, he reproduced the stains and wear on the specific prints that he viewed.

Art generated through craftsmanship can be appreciated for a beauty born of discipline, skill, and the fusion of finely made tools with the dexterity of their user. In Bidou's case, such artisanship also renders afresh the wonder of the masks, paintings, prints, or even persons being re-created. This beauty of artistic process is linked to larger ideas of beautiful objects as the product of effort, whether human or divine. Although Noh masks include images of beautiful women and men, they also feature the demonic and horrific. However, in his choice of western female portraits, Bidou allies his art with European canons of beauty that champion women as a reflection of moral and even spiritual ideals that connect the artistic object, artist, and viewer.[13] Beauty as a product, like the craft process, not only brings immediate pleasure that is an end in itself but also points to the life-affirming role of beauty.[14]

With its obvious emphasis on craft and beauty, Bidou's work engages the pre-modern definitions of art that informed the works he adapts. The art philosopher Dennis Dutton has defined a "cluster criteria" for art across cultures. In many ways this broad definition of art applies to Bidou's work as well as to the European portrait tradition and to Noh masks. Dutton's characteristics include direct experiential pleasure of the thing itself, divorced from utility and deepened by complexity and interdependence of formal elements; the artist's specialized skill (whether innate or learned) and technical virtuosity; a style that operates within a familiar horizon of expectation; novelty and creativity; an evaluative critical discourse; imitative representation of familiar things; special status created by being separated from ordinary life; the ability to express personality; emotional saturation created through content or style; perceptual and intellectual challenge; familiarity within socially constructed traditions and institutions; and, most importantly, "an imaginative experience for both producers and audiences."[15]

Even as Bidou's work reifies many of the perceptually and socially constructed definitions of pre-modern art, it also engages with contemporary theories of art. Most basically, it raises the issue of simulacrum. It is possible to see in Bidou's art examples of Gilles Deleuze's inversion of Plato's formulation of likenesses (eikons) and distorted semblances (simulacra), meant to liberate art from the privileged positions of hierarchy and essence based on foundational western ideas of originals and copies, models and reproductions. Less positively, Bidou's modern portraits might be read in terms of Jean Baudrillard's notion of simulacrum as hyper-reality.[16] However, imbued with Noh's aura of ghostly forms that both hide and reveal shifting identities through masks, and with East Asian cultural norms that champion rather than denigrate reproduction, this hyper-reality may well be part of the world of speculative fiction where such images live in a "virtual reality" beyond simulation or dissimulation.[17]

## 4. Appropriation

Whatever theoretical associations of originals and copies might be made in light of shifting western and Asian norms, there is no doubting that, in the early twenty-first century, it is impossible to look at a face of *Mona Lisa*, *Venus*, or *Girl with a Pearl Earring* and not think of generations of representations in art, film, cartoons, commodities, and other manifestations of "popular culture." Similarly, an exhibition of contemporary interpretations of Sharaku's iconic portrait prints has been circulating internationally since 1996.[18] Further, Bidou's mask of a film star, *Angelina* [cat. 20], inevitably invites comparison to sculptures of celebrities by Jeff Koons (b. 1955) and Daniel Edwards (b. 1965). Thus, Bidou's work can be read as an imaginative evolution within traditional Japanese Noh mask making, a commentary on cultural authority, and a Pop mash-up in which the ironic turn and semiotic revision are reborn in yet another incarnation.

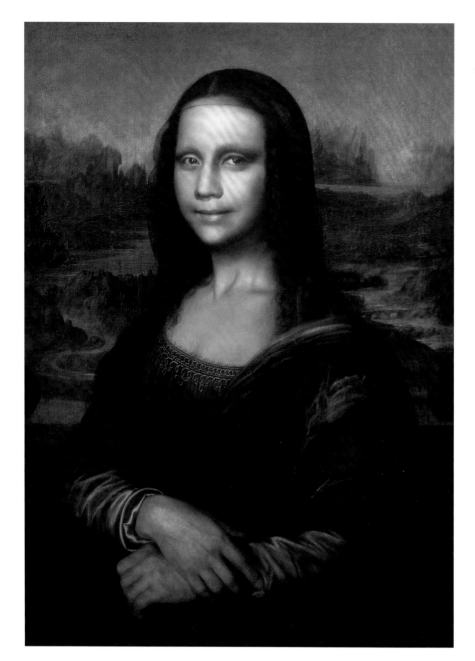

Fig. 7

Morimura Yasumasa
*Mona Lisa In Its Origins*, 1998
Color photograph on canvas
30.5 x 21.5 in.

Bidou's sculptural subjects are not merely icons but hyper-icons. When viewed apart from his Noh masks, they invite reading through the filters of Modernist and Post-Modernist discourse. That his first work was *Mona Lisa*, the iconic and iconographic example of simulacra, underscores the value of such interpretation. To look at Bidou's *Mona Lisa* is to see Leonardo's *Mona Lisa*, but more immediately, it is to imagine it within a seemingly infinite unfolding of appropriations. These Mona Lisas extend from the ready-made *L.H.O.O.Q.* (1919) by Marcel Duchamp (1887-1968) to *Thirty Are Better Than One* (1963) by Andy Warhol (1928-1987) to the recent "provocations" by Banksy (b. 1974).

There is even a trajectory of *Mona Lisa* appropriation in Japan. Beginning perhaps with *Pneumonia Lisa* (1982), made by Robert Rauschenberg (1925-2008) with the Japanese Recreational Clayworks and including Japanese imagery, it includes *Resting Model* (1999) by Miran Fukuda (b. 1963) and is most famously witnessed in the 1998 trio *Mona Lisa in Its Origin* [fig. 7], *Mona Lisa in Pregnancy*, and *Mona Lisa in the Third Place* by

Morimura Yasumasa (b. 1951). Japanese fascination with *Mona Lisa* culminated in the exhibition *Les 100 Sourires de Mona Lisa* (The 100 Smiles of Mona Lisa). Displaying more than 100 *Mona Lisa* variations, the show attracted more than 110,000 visitors during its fifty-day run at the Tokyo Metropolitan Art Museum in 2000.[19] Although Bidou's fascination with the *Mona Lisa* pre-dated the exhibit by several years, that display of *Mona Lisa* appropriations may well have inspired his *Mona Lisa* made three years later.

Bidou's other sculptures also exist within the multilayered realm of contemporary cross-cultural appropriation. For instance, Morimura's *Art History* series includes *Vermeer Study: Looking Back (Mirror)* (2008), a digitally produced picture of Morimura as the subject in *Girl with a Pearl Earring*. Appropriation works best when the original sign is incomplete, and thus more easily open to shifts and distortions in its semiotic function.[20] Thus, it is worth noting that the identity of the sitter is debated in most of the paintings appropriated in Bidou's *European Painting* series. As a result, the images are paradoxically familiar and mysterious. In similar fashion, for his *Ukiyo-e* series, Bidou focused on prints by Sharaku, whose enigmatic shadow is cast over his portraits of well-known actors.

Because (re)presentation of canonical images is an "archetypal act,"[21] it calls attention to the power exercised by the appropriator over the appropriated. Edward Said's analysis of Orientalism has produced a flood of writing on the Euro-American appropriation of Asian art. The art of Bidou and other Asians may be seen as reversing this flow. However, compared to the work of Morimura and other Japanese artists who use western or "universal" media, Bidou's masks operate in at least three distinct ways.

First, most artistic appropriations use mass reprographic techniques (photography, silkscreen, digital art) to reproduce paintings. In contrast, Bidou's handmade sculptures deviate from this mechanical dissemination to re-create the tactile qualities of the paintings. Thus, they create an intimate connection with the originals even as they break from them by returning the human subjects to corporeal form.

Second, Bidou's focus on *utsushi* (reproduction) erases obvious signs of his own hand and authorial presence. The antithesis of Morimura's insertions of his own face and persona into art history, Bidou's visages are not overtly personal expressions. Neither are they accompanied by a manifesto that evinces a single ideology. Moreover, in some contexts, viewers may wear them in order to temporarily adapt new identities. And, although not intended for use in plays, as masks they might easily function that way, and be given new thematic content. Because they are "open," they better avoid the heavily "contextual and historical" circumscription of most art based on appropriation. As Robert S. Nelson maintains, most "appropriations, like jokes,...do not travel well, being suppressed or altered by new contexts and histories."[22]

Third, by appropriating markers of western civilization within the specific form of the Japanese Noh mask, Bidou's *European Painting* series adds the weight of tradition to potential cultural critiques. For instance, these masks might initiate an investigation of how western appropriations alter the associations of Asian cultural forms, like Noh masks, that were created for use. Thus, Noh masks are displayed in the British Museum with the implication of fine art, collected by the Victoria and Albert Museum under the rubric of craft, and exhibited at Oxford's Pitt Rivers Museum as ethnographic artifacts.[23]

## 5. Portraiture

Even as Bidou's disembodied faces exist in a chain of art historical references, they also refer to the persons they depict. Like most portraits, their interest derives in part from this "oscillation between art object and human subject."[24] The powerful presence of the

"base" portraits may indicate a primary orientation to those art objects rather than to the sitters. However, the works' status as potential Noh masks—with the implicit function of conveying the stories of actual people—points to a different trajectory. Hence, it is useful to analyze some of the ways in which they function as uncanny likenesses: portraits made with no direct experience of the subjects but conveying the weight of their souls.

Writing about Warhol's silk-screened images of Marilyn Monroe, Richard Brilliant concludes that they are "about image-making rather than portraiture because the work so clearly emphasizes the mechanism of popular representation in the modern age but not the person being represented." Mechanical reproduction, he continues, "inevitably erodes the status of an original, even *the* original in the portrait."[25] Stripped of much of the "deeper referential component," such works struggle to carry out the basic functions of western portraiture. By contrast, Bidou's manual reproduction of fine details in the original paintings reinforces the status of the original portrait and the sitter. More powerfully, the plasticity of Bidou's masks—allowing observers to gaze at Lisa Gherardini, the Mona Lisa, in profile and three-quarter view for the first time since her death—gives his sculpture a compelling claim on portrait representation as it existed in Europe until the modern age.[26]

That tradition is defined most basically as art works that represent living or once living people by artists for an audience, and express concepts of individuality and identity that revolve around appearance, name, social function, pertinent characterization, and consciousness of distinction. These concerns are encapsulated by three questions: "What do I look like?" "What am I like?" and "Who am I?" Yet, portraiture seeks to transcend immediate concerns, and the ravages of time, to present a sense of an inner character or holistic identity imagined as the eternal soul.[27] If a portrait belongs to the memory of the person being represented rather than simply to given realities,[28] then the temporal, spatial, and cultural distance of Bidou's works does not remove these portraits from their original subjects. Further, because both European portraits and human-based Noh masks balance denotative interest in the individual with connotative emphasis on the type within established categories (young beauty, kindly mother, suffering spinster, etc.), the gap spanned by Bidou's cross-cultural art is not so great.

Noh masks, although far more stylized than most European portraits in terms of their emphasis on types, not individuals, share with portraits several characteristics that help explain the naturalness of Bidou's translation between forms and cultures. First, just as orthodox western portraiture insists on a correspondence with real appearances, Noh masks capture a "subjective realism more in keeping with Eastern concepts of reality." Mark Nearman elaborates, "However symbolic or abstract these artists' expressions may appear from a present-day perspective, in medieval Japan they were not so viewed by artist or spectator."[29] Both artistic modes also control human faces for similar purposes. Portraits and Noh masks of humans typically avoid dramatic expression of feelings that would tie the image to the particular and transitory rather than the desired evocation of the stable and eternal. These neutral or "sanitized" facial expressions, like the famous "indeterminate expression" (*chūkan hyōjō*) in Noh masks of young women, allow the portrayed figure to adapt to various social attitudes and relationships. Mask and portrait alike play between prideful artificiality and an uncanny resemblance to life, though the Noh mask does so best when worn by an actor who bends and turns in flickering light.

In his analysis of European portraits, Richard Brilliant first likens the familiar mute expression to a mask that functions as a social disguise. He extends the portrait-as-mask metaphor, acknowledging the power of masks to reveal. He also notes the artificial nature of both portrait and mask as devices for negotiating the internal and external

(or social) aspects of identity.[30] Although the mask serves as a metaphor for portraits of all kinds, it becomes literal in many portraits made early in the modern era, when ideas of artistic form and identity differed markedly from those based on Renaissance humanism. The ideal of the stable self captured in a portrait gave way to a dynamic and perhaps unknowable persona further destabilized in artistic interpretation. In the age of the id and the ego, DNA, plastic surgery, and Photoshop, the external appearance holds ever less significance—and the idea of external form as a provisional mask holds greater sway.[31]

Beginning with Picasso, modern artists making portraits employed "primitive" masks as substitutes for actual faces and as strategic means of abstraction. The mask denies a stable essence and the realism used to project it. Instead, masks conceal certain traits, reveal others, and project desires. Able to be substituted, and used temporarily, masks capture the fluidity that defines modern identity. The abstraction of the mask also creates a tension with the specificity demanded of the portrait to embody the anxiety ascribed to modern life.[32]

Noh masks share with modern portraits the qualities of concealing, revealing, and projecting identities. They project the temporary appearance of unstable characters whose dramas reveal "conflict between one's formal place in life and one's ability to imagine oneself more broadly…".[33] Noh masks, however, operate in ways that point directly to the complexity of identity. Hung on the actor's face but not fully covering it, the Noh mask is an outer form animated by the inner life of the actor's performance; it is also assumed to possess an "independent life" that informs and impacts the actor. Formally, the exaggerated shapes and expressive or symbolic colors deployed in Noh masks of spirits and demons parallel the abstracting strategies of modern painting, which itself is grounded in the anti-naturalistic aesthetic of masks and, before that, Japanese prints. Art historically, the prints by Sharaku adapted in Bidou's *Ukiyo-e* series [cats. 22, 24, 26, 28] impacted the paintings by Munch, Klimt, and Modigliani [cats. 17, 18, 19]. In Bidou's professional trajectory, the causality is reversed, with the abstract *Jeanne* [cat. 19] seeming to inspire the distortions of the *ukiyo-e*–inspired works.

Despite these points of confluence, the Noh mask form differs from both conventional and Modernist portraits in important ways for Bidou's work. Most portraits connect faces with bodies. One art historian writes, "It is obvious that body-language crucially completes the information conveyed in a portrait, which loses force if it is limited to the face or if the face is represented in an inanimate way. To show the face as immobile and hieratic is to show it without a soul."[34] Moreover, painted portraits place the body in an environment. Portraits thus rely on gesture and context that can be encoded with markers of status, character, and even basic identity. Usually commissioned by an individual or group associated with the subject, the portrait is meant to serve a commemorative function within a circumscribed space.

By contrast, Bidou's work is cut adrift physically and socially. The fame of its source images allows a degree of connection to such denotative concerns, but its achievement is its connotative value. Despite the above claims for the body in portraits, the logic of the Noh mask works in the opposite direction. The reduction of the physical form acts to compress and intensify its affective power. In the mask, the face is divided into three components: the forehead and eyes comprise the most spiritual part; the nose constitutes the most sensitive; and the mouth is the most sensual. In this arena of minimal form and maximal effect, even the ways of representing eyebrows and hair convey information.[35] The haiku-like abbreviation of Noh masks, together with the Noh legacy of presenting transient souls, projects the women in Bidou's portraits well beyond a single time or space and lends them a spiritual dimension that is perhaps universal.

## 6. Noh Form

Thus far, this essay has presented Bidou's work in terms of his evolution from disgruntled graphic designer to reproducer of Noh masks to sculptor of contemporary art informed by a craft ethos, even as it engages with issues of appropriation and portraiture. Noh has been positioned passively, an unchanging tradition to be challenged, and a repository of ideas that are discovered to parallel or resonate with other artistic practices and forms. This section examines Noh—or its recent reinterpretations—as a more active force in Bidou's work and its interpretation. It first provides a kind of visual field for Bidou's new masks by tracing various ways in which Noh and Noh masks have spurred modern and contemporary art making in Europe, America, and Japan. It then investigates Noh as a model of creative practice before turning to the thematic content of Noh plays that take women as their subject.

In Europe, Noh was an important factor in the creation of modern performing arts. Ezra Pound (1886-1972), W. B. Yeats (1865-1939), and Bertolt Brecht (1898-1956) admired Noh for its distanciation effect, which could be deployed against the Aristotelian idea of empathy as the foundation of drama. Noh masks were praised for the dramatic power of their dissimilitude, which overturned the long dominance of verisimilitude in western theater. In his 1926 play *The Great God Brown*, Eugene O'Neill (1888-1953) used masks to this end, writing, "The mask *is* dramatic in itself, *has always* been dramatic in itself, *is* a proven weapon of attack. At its best, *it is* more subtly, imaginatively, suggestively dramatic than any actor's face can ever be. Let anyone who doubts this study the Japanese Noh masks."[36]

In modernizing Japan, Noh occupied a more fraught position, cited by some as an atrophied relic of the past and others as the heart of a vibrant heritage. An example of the first attitude is found in the writing of *mingei* (folk art) theorist Yanagi Sōetsu (1889-1961). Despite praising Noh as "an art almost without parallel in the world [and] one of the peaks of Oriental art in which the spirit of Zen is expressed," Yanagi challenged lovers of hidebound Noh to visit Okinawa to "watch song and dance, night by night, sparkling and living with an ancient grace and vitality."[37] Conversely, for cultural historians and philosophers invested in discovering Japan's putative essence in its medieval, Buddhist-saturated aesthetics, Noh played a positive role as the theatrical expression of Zen. In the words of Hisamatsu Shin'ichi (1889-1980), not only is every aspect of Noh performance informed by Zen, but "the Fundamental Subject of expression in Nō is Zen."[38] Beyond such simplistic reductionism, Noh is frequently cited as embodying attitudes and practices that remain relevant for contemporary creation. Architect Kurokawa Kishō (1934-2007) credited the Noh theorist Zeami's "interval of no action" (*senuhima*) in performance as crystallizing the Buddhist concept of emptiness (*sunyata*) that informs Kurokawa's own architectural philosophy of "transitional, complex, silent, multivalent space."[39]

Relative to its substantial impact on theater, dance, and music, Noh played a minor role in mainstream Modernist visual arts in Europe and America. In rare pictorial works like *Noh Flower,* a *sumi* ink painting from 1954 by Morris Graves (1910-2001), Noh seems an offshoot of Zen, though perhaps the work has deeper ramifications in its allusion to Zeami's concept of "flower." In midcentury Japan, Noh's new status as an intangible cultural property with its own national theater led to several types of visual expression. Extending the approach of Tsukioka Kōgyo, several artists designed naturalistic images of signature Noh roles for reproduction in woodblock prints that were likely sold at Noh performances.[40] More progressive artists used Noh to visualize the controlled energy that purportedly linked Zen modes of expression with modern ideas of

spontaneous gesture. These abstract prints—exemplified by *Noh Actor* of 1958 by Yamaguchi Gen (1896–1976) and *Noh Play (B)* of 1960 [fig. 8] by Takahashi Rikio (1917–1999)—provide a dynamic balance to static prints of stone gardens produced at the same time.

While Noh was drawn into the powerful orbit of Zen, it also was used to explore Japanese psychological themes and a native taste for evocation and implication. Novelist Enchi Fumiko (1905–1986) used three types of Noh masks to structure the narrative in *Onna-men* (Woman Masks, 1958).[41] In 1944 the reclusive oil painter Sakamoto Hanjirō (1882–1969) began enigmatic depictions of Noh masks, and their boxes, to explore the idea of *bukkan,* a "feeling for things" that transcends the physical.[42] The cultural and psychological power of Noh masks informs the work of graphic designers

who made international names in the 1950s and 1960s. Although Awazu Kiyoshi (b. 1929) and Yokoo Tadanori (b. 1936) created notable posters featuring Noh masks, most iconic are Tanaka Ikkō's silkscreen posters. Made for the Kanze school Noh performances sponsored by the Sankei newspaper company from 1958 to 1982 [fig. 9], most feature close-ups of female Noh masks, mixing these commanding faces with bright colors and spare, modern typefaces to suggest Japan's timeless modernity.[43]

For Japanese artists in the immediate post-war decades, Noh masks signal the permanence of Japanese cultural forms and values. In stark opposition, a younger generation of artists on both sides of the Pacific use Noh masks for their phantasmic qualities of indeterminacy, mutation, and decay. In such video performances as *The Inn of Floating Imagery* (2007) and *The Cathedral of Emptiness* (2008), Kathy Rose (b. 1949) creates surreal environments of floating forms inspired by the "mystery of Noh." In them she frequently uses Noh masks in addition to her own ghostly, mask-like visage.[44] For his 2008 series *SP Extra Malformed Noh-Mask* [fig. 10], Odani Motohiko (b. 1972) made sculptures that appear to re-create Noh masks and then deform them. Through beautifully macabre images of masks with the "skin" peeled open to reveal the musculature of the human face, or fractured to create multiple forms, Odani transforms Noh masks in ways that resonate both with contemporary fantasy culture and with Buddhist laws of transience.[45]

Despite the dramatic power of these works, they avoid the narrative content of Noh masks. In contrast, British artist Simon Starling (b. 1967) deploys newly conceived Noh masks to tell stories. In his installation *Project for a Masquerade (Hiroshima)*, made for the Hiroshima City Museum of Contemporary Art in 2010–11, Starling remade the Noh play *Eboshi-Ori* (The Hatmaker) to tell a fictionalized Cold War tale of Henry Moore's creation of the sculpture *Atom Piece* (1964–65). Starling's account is "told" through masks of his characters, including Moore (1898–1986), physicist Enrico Fermi (1901–1954), fictional agent James Bond, and art historian–spy Anthony Blunt (1907–1983). The masks were presented together with a film, showing Osaka Noh mask maker Miichi Yasuo (b. 1950) creating the masks, and a booklet that explains the narrative.[46] For Starling, the *Project* has the potential to live beyond the exhibition through actual performances of his libretto.

Starling's desire to have actors perform in masks suggests a potential future for Bidou's work. This return to the theatrical function of Noh masks is already realized in two noncanonical masks created by Noh mask maker Kitazawa Hideta (also known as Shūta; b. 1968). In 2011, Jubilith Moore, director of Theatre of Yugen in San Francisco, commissioned Kitazawa to create two masks for Erik Ehn's modern Noh play *Cordelia,*

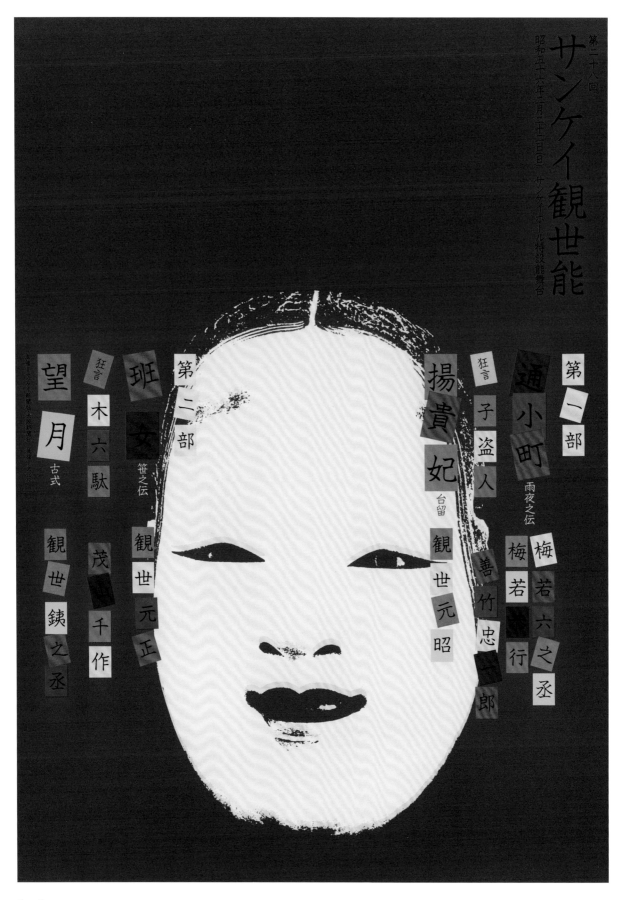

FIG. 9

Fig. 9

Tanaka Ikkō

*Kanze Noh Play*, 1981

Offset lithograph

40.5 x 28.625 in.

Gift of the designer
The Museum of Modern Art, New York,
NY, U.S.A.

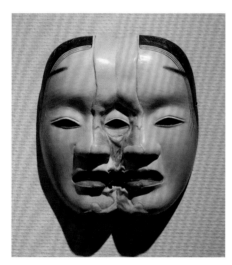

Fig. 10

Odani Motohiko

*SP Extra Malformed Noh-Mask
Series Half Skeleton's Twins: Tosaka*,
2008

Wood, natural mineral
pigment, Japanese lacquer

8.46 x 7.68 x 2.76 in.

adapted from Shakespeare's *King Lear.* Kitazawa's two masks—Cordelia as princess, and Cordelia as warrior [fig. 11]—inflect female Noh masks with the appearance of European heroines, based on images sent by Moore to Kitazawa. The result is an East–West fusion befitting the play.

The multiple forms, contexts, and meanings given these transformations of Noh masks provide a visual field for understanding and evaluating Bidou's accomplishment. It is easy to imagine the likely impact of Tanaka's Noh posters on Bidou as a young student of graphic design. Photos of Kitazawa's mask worn by actors hint at the new kinds of beauty that might emanate from Bidou's *Mona Lisa* [cat. 11] or *Angelina* [cat. 20] if glimpsed in a Noh performance. Starling's inventive narrative, given startling face by Miichi, suggests how Bidou's diverse cast of iconic European women, or Kabuki actors, might be imagined in dramatic conversation. And the overt mutation of Odani's phantoms focuses attention on the effects of decay in Bidou's obsessive reproduction of wear and age as not only fidelity to his European sources but, more importantly, as links to the idea of transience central to Noh. Although collectively these works demonstrate the creative energy found in art *about* Noh, many of them seem somehow extraneous to it. Arguably, Bidou's work, made with the process and the form of Noh masks, more fully embraces the complex soul of Noh.

## 7. Noh Spirit

Like other medieval Japanese art forms, Noh demands obedience to fixed forms *(kata)* in its performance and in the creation of its attendant objects. In Noh and related arts like tea ceremony, new creation takes place within a matrix of fundamental patterns that must be mastered. As Charles Inouye writes, "Constant repetition leads to the ability to adapt. The fixed leads to the brilliance of the fluid."[47] This seeming paradox in creative process is paralleled in the content of Noh. There, intense spiritual conflict leads to wholeness, and vigorous action and sound culminate in a point of silent stillness that "makes a moment of singularity an eternally reverberating one."[48] The atmosphere of mystery gives way to clarity, and through a process of transformation, humans find their true form. For all the textual allusion and formal rigor, Noh plays are concerned above all with "states of mind" and conditions of being.

Bidou's art is imbued with the sense and sensibility of Noh. His "creative" art grew out of Noh mask making, and these pieces are made alongside conventional masks. They retain the form and process of Noh masks as well as their deeper ethos of *utsushi*. They embody the fundamental idea that reproduction is not mere copying, but a means of incremental alteration and inescapable interpretation. In this form that seems so alien to contemporary ideas of artistic creation and meaning, there exists great potential for creativity and expression. Noh literally means "talent," implying skill or artistry as well as a sense of transcendence.

As the catalogue entries here demonstrate, Bidou's art also achieves its power through a rich polysemy of intermingled emotions, allusive connections, and crossed dimensions similar to the intertexuality of Noh plays. Like much of Japanese cultural creativity, it is premised on a "philosophizing in the archaic."[49] Woven like tapestries out of older works of poetry, religious text, narrative tale, and folk story, Noh plays strain the connotative power of words. In like fashion, Bidou's art connects with earlier objects, signals its aesthetic pedigree, and establishes thematic resonances. Even with this

referential quality, the successful work of the dramatist and the artist maintains the ability to arrest the observer in the present moment. Bidou's masks, like Noh plays, invoke time and suspend it.

Placing Bidou's *European Painting* series thematically in the context of Noh underscores his subtle enquiry into the character and spirit of the subjects. His evocations of famous European women employ the three-dimensional form and the otherworldly stillness of Noh masks to reconnect viewers with these women as humans. (That they were initially given artistic form through the efforts of great artists multiplies the power of the mask.) Looking at these silent faces, we understand the Noh actor's  statement that the "independent mind" of the mask speaks through the creative power of its maker.[50] Although these European icons do not share Noh's Buddhist worldview, they resonate with its spiritual aura—and belief in salvation—to forge a link between Buddhism and Botticelli's Neoplatonism, Michelangelo's Catholicism, Leonardo's humanism, and Munch's mysticism.

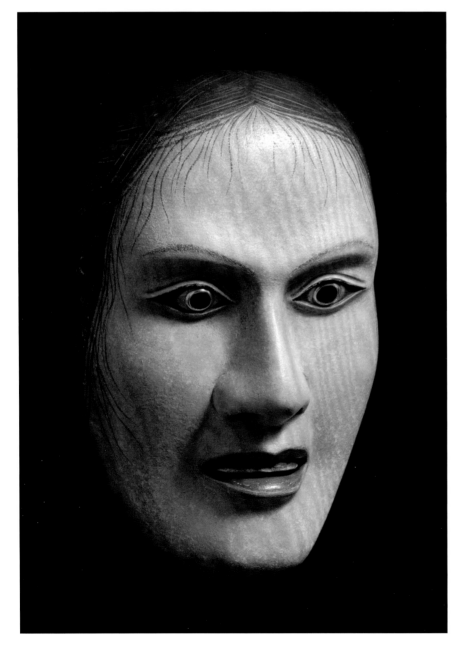

Fig. 11

Kitazawa Hideta

*Cordelia Nochi-shite mask*, c. 2011

Paulownia wood

8.75 x 5.5 in.

Property of Theatre of Yugen

It is telling that Bidou's first new masks engage female subjects. Women form a special category in Noh, and these "woman plays" are often wrenching explorations of the weight of being in general and the "complex psyche of women" more specifically. Woman plays fall within the Noh categories of plays about living beings (*genzai*) and about spirits (*mugen*), in which the lead character/doer (*shite*) appears as an ordinary human but then reveals her true identity as the ghost of a woman from the past. In Noh, women attained a new status within Japanese society as "individuals endowed with subjectivity."[51] In the plays, as in the earlier literature that they adapt, women's identities are contingent and evolving, by turns concealed and revealed.[52] In Thomas Rimer's analysis, because the internal tension in Noh is located "within the central character, not between two characters," Noh plays share important similarities with western portraits, not with western drama.[53] This quality of eliciting the stories behind the face marks a critical component in Bidou's Noh masks as "deep portraits."

In her study of Noh woman plays, Etsuko Terasaki elucidates themes of "sexuality, desire, fantasy, madness, spirit possession and mourning."[54] The women in Bidou's *European Painting* series evoke many of these characteristics which are perhaps intensified, given that most of these women were in fraught love relationships with the artists who immortalized them. In their first artistic life as paintings, these women stand, in part, for enduring cultural values or ideals of womanhood. Reincarnated as Noh masks, they take on the liminal status of ghosts or spirits. As disembodied and displaced projections of real humans, they are able to enter new realms. In shifting the physical materials, spatial dimension, and cultural context of these females, Bidou creates new intimacies and suggests deeper mysteries. Viewers gain knowledge of these women in new ways, literally viewing their faces from new angles. This transformation reinforces their iconicity and destabilizes their meaning.

This fluidity increases dramatically when we consider these sculpted portraits as the subjects of new Noh plays. Used by an actor, speaking through the mask like a spirit speaking through a human medium, these faces may project specific although temporary content. Those words, disclosing fears and dreams, facts and feelings, add the counterweights of history and imagination to Bidou's portrait interpretations. In putting flesh on the portraitist's question, "What do I look like?" Bidou complicates the attendant queries, "Who am I?" and "What am I like?" As the faces of imagined Noh characters, these women express not the singularity of historical narrative but the plurality of creative discourse.

## 8. BEYOND *UTSUSHI*

Because *utsushi*, or creative reproduction, is a key concept for Bidou,[55] *Angelina* [cat. 20] is a notable exception. It neither reproduces an iconic work of art nor shows Angelina Jolie (b. 1975) in a signature film role. An idealized image based in part on various photos, it does not present the subject's actual appearance. Despite these differences, *Angelina* resonates deeply with Bidou's other work. Topically, the mask is linked to the female icons in the *European Painting* series and the popular actors in the *Ukiyo-e* series. Thematically, it is Bidou's work most directly informed by Noh. *Angelina* underscores the rich discursive potential in all of Bidou's art.

In a recent interview, Bidou stated that he would like to make masks for new plays.[56] Although not commissioned for a performance, *Angelina* imagines the iconic actress-humanitarian in the world of Noh. Jolie's face is presented frontally in the manner of Noh masks, even as Bidou radically transfigures it into a composite of two Noh masks: the downcast eyes of the prince Semimaru, and the horns of jealous yet sorrowful

Hannya. Like many Noh masks, one imagines the image informed by multiple texts. Some might evoke Japanese legends of beauties who reveal their true form as demons, marked by horns of jealousy. Others might tell of passion overcome by the wisdom (Sk. *prajñā*; Jp. *hannya*) that leads to enlightenment. Hannya is the name of not only a Noh mask/character but also the female divinity Prajñā-pāramitā (Jp. Hannya-haramitta; "Perfection of Wisdom"), who personifies wisdom. More broadly, we might imagine *Angelina* within a Buddhist pantheon of female divinities, including Hārītī (Jp. Kishimojin), an ogress-turned-protector-of-children, and the tantric, horned, wisdom goddesses called *dakini* (Jp. Dakini-ten, "sky dancers"), linked in Japan with shape-shifting foxes.

 *Angelina* bears the faint smile of a bodhisattva (Jp. *bosatsu*), an enlightened being whose compassion leads him/her to remain in the physical world. Usually depicted as an elegant, even sensuous, aristocrat, the bodhisattva image is found across the Buddhist world. Given Jolie's deep professional and personal connections with Cambodia, and her own striking physiognomy, the mask may recall Khmer dynasty sculpture, marked by full lips and idealization. For some, it may even resemble the famous "double portraits" of Khmer god-king Jayavarman VII (1125–1218) as bodhisattva Lokeśvara that emanate from the towers of Angkor Thom's Bayon temple—a site featured in Jolie's transformative film, *Lara Croft: Tomb Raider* (2001).

 For viewers familiar primarily with contemporary art, and the kind of titillating sculptures of celebrities associated with Koons and Edwards, *Angelina* may well appear as an odd mix of Japanese craft and neo-Pop art. Deeper interpretations require familiarity with Japanese culture and Buddhist art. These contrasting readings suggest the wide-ranging knowledge required to read subtlety and complexity in Bidou's art. *Angelina* epitomizes the syncretic quality of Bidou's art that is premised on fundamental connections between the realms of secular and sacred, Asian and western, traditional and contemporary, popular and élite.

## 9. CONCLUSION: BEYOND TRANSGRESSION, TRANSFIGURATION

Within the conventions of sculpture in the early twenty-first century, Bidou's work recalls an earlier age, its values and methods now termed "academic" in contrast to the overt qualities of transgression that have long defined the avant-garde. With their nonironic embrace of history and definition of art premised on beauty and skill, Bidou's masks are meant to illicit pleasure rather than pain. Their highly finished surfaces, the result of painstaking labor, contrast with both the rough edge of subversive art that short circuits "mere" technical skill and those machine-made works that trade ironically on the presumed banality of beauty. In an artistic age that revels in mocking disbelief, Bidou's masks are calibrated to elicit wonder through the exploration of human emotion. Thus, Bidou's work runs counter to the acerbic mood and the conceptual foundation of most contemporary sculpture. It embraces, in part, the craft ethos of Noh mask carving and the "academic" conventions of European painting. In sum, it rejects the anti-art stances of reflexive oppositionalism in form and in cultural politics.[57]

 For all its conservatism, Bidou's work is transgressive in at least two ways. First, for a Noh mask artisan, making new work overturns the idea of creation as only the reproduction of existing masks. Second, Bidou's themes are a kind of provocation, an invitation to imagine distinct worlds conjoined in serious ways. In his *European Painting* series, he places in relation two conceptual discourses, the stylistic "progress" and "objective insight" of western painting and the assumed stasis and "subjective formalism" of Noh masks and Asian "traditions." In the *Ukiyo-e* series, Bidou connects the opposing

categories of plebian Kabuki and aristocratic Noh. In both series, one sphere trespasses into another.

Yet, Bidou's transgressions, though real and perhaps profound, are muted and masked by his abiding respect for the works and worlds that he transforms. This is transgression of a type and tenor different from the strident adversarialism of late Modernism in its long journey from Georges Bataille's undermining of nineteenth-century academism through the embrace of the violent, abject, and erotic. Instead of trafficking in dread and ecstasy, Bidou's transfigured portraits mix mystery with radiance. They fit Jane Bennett's category of works that are "disturbing-captivating," as opposed to those that are "disturbing-repelling," and they follow Anthony Julius's statement that "Art can have an estranging effect, certainly, but it can also tame, and make the remote accessible. It is one method by which we can acquire knowledge of the hitherto intimidatingly alien."[58]

In the world of Noh, Bidou's work challenges the conventions of Noh masks and, by extension, might stimulate new types of Noh plays. More expansively, Bidou's art suggests ways of deploying the aesthetic strategies and ontological assumptions of Noh. This is not simply another strategy for "modernizing within tradition" in Japan, or a new manifestation of Japanese cultural uniqueness with universal application. Despite the large implications and assumptions sketched in the preceding section, in this opinion, Bidou's work is not aimed at any totalizing theory about contemporary art practice, and certainly the artist has produced no manifesto to such an end.

Instead, Bidou Yamaguchi's art seems focused on a particular task. Bidou's masks are a kind of artistic intercession on behalf of half-human, half-artistic spirits. His works are transfigurations that bring about reincarnations into a transformed body (keshin) that is the true body (hontai) for figures like Lisa Gherardini who have become so well known as images (the Mona Lisa) that they all but cease to exist as humans. This act is analogous to the procedure of intercession or recuperation in the texts of Noh plays. However, unlike Noh plays, where this literary rebirth recuperates the socially unacceptable acts and desires of women and other marginalized figures,[59] Bidou gives a new body—literally, a face with the potential of speaking—to persons who have been turned into "ghosts" by mechanical reproduction, popular appropriation, and, perhaps, a deeper unwillingness to comprehend the humanity of people removed from us in time and place.

Bidou's art constructs a three-dimensional face for these rhetorical ghosts, and thus brings about an altered understanding of these persons who have become so familiar as images that they are almost invisible as the vestiges of souls. Although Bidou's art is rooted in a Buddhist worldview, it resonates with the Christian idea of transfiguration as a change in form or appearance that parallels a spiritual change, and it signals the exultant moment when the human meets the divine so that the temporal becomes eternal.

# Notes

1. For instance, the artist's website (http://www.bidou-yamaguchi.com) contains several statements by the artist not addressed here. Interviews with Bidou were conducted by Kendall H. Brown in New York on March 15, 2013; by William T. Vollmann via e-mail in May 2013; and by Matthew Welch via e-mail in July and August 2013.

2. Contemporary Japanese adaptations of Sharaku's prints, including work by Murakami Takashi and Morimura Yasumasa, comprised the traveling exhibition *Sharaku Interpreted by Japan's Contemporary Artists*, first organized by the Japan Foundation in 1996, with a catalogue edited by Ito Masanobu and then revised in 2009.

3. For Ayomi's life and art, and that of her illustrious family, see *A Japanese Legacy: Four Generations of Yoshida Family Artists* (Minneapolis: The Minneapolis Institute of Arts, 2002).

4. Gendou was a student of Noh mask maker Nagasawa Ujiharu (1912–2003), who had been awarded the status of Living National Treasure *(ningen kokuhō)* in 1979.

5. Jeanne Nishimura summarizes the rigid world of Noh mask making thus: "The world of Nō mask carving is traditional and rigid. There is no freedom to create new works.… Traditional carvers…believe that the artistic spirit of any Nō mask maker should never allow him to deviate from duplicating the original models of the masters. The art is to reproduce the classic originals." Nishimura, "A Life-Giving Art: Traditional Art of Nō Mask Carving," in *Nō/Kyōgen Masks and Performance: Essays and Interviews*, ed. Rebecca Teele, special issue of *Mime Journal* (Claremont, Calif.: Pomona College Theater Dept. for the Claremont Colleges, 1984), 140–47.

6. This act recalls the portraits of Kishida Ryūsei (1891–1929), who captured friends and family with reference to the work of Dürer, Holbein, and van Eyck before turning to the thirteenth-century Chinese painter Yan Hui.

7. This theory, first advanced in the early nineteenth century, is supported by Tazawa Hiroshi in the exhibition catalogue *Sharaku* (Tokyo: Tokyo National Museum, 2011).

8. For a broad discussion of the shifting definitions of art, and the ways in which the current use of the term jettisoned earlier meanings that stressed technique and utility, see Larry Shiner, *The Invention of Art: A Cultural History* (Chicago: University of Chicago Press, 2001). For the adoption of European ideas of fine arts in Japan, and the impact on "craft," see Dōshin Satō, *Modern Japanese Art and the Meiji State: The Politics of Beauty,* trans. Hiroshi Nara (Los Angeles: Getty Research Institute, 2011).

9. For this idea in Asian art, see the introduction in Lothar Ledderose, *Ten Thousand Things: Module and Mass Production in Chinese Art* (Princeton, N.J.: Princeton University Press, 2000).

10. John Ruskin is credited with the saying, "Quality is never an accident. It is always the result of intelligent effort. There must be the will to produce a superior thing."

11. David Esterly, *The Lost Carving: A Journey to the Heart of Making* (New York: Viking, 2012), 214. In the contemporary age of conceptual art, Esterly writes: "Skill is worse than unnecessary. It sends out the wrong signals. Often as not it's a term of condescension among contemporary art critics. Skill is the folk costume donned by sculpture when it leaves the world of thought and wit and irony and descends to craft. The only craft should be the craftiness of the conceit" (194).

12. For a more detailed description of the painting techniques and their expressive effects, see Stephen E. Marvin, *Heaven Has a Face, So Does Hell: The Art of the Noh Mask* (Warren, Conn.: Floating World Editions, 2010).

13. For a discussion of the tangled relationship between art, beauty, and women in the twentieth century, and a call for the resurrection of beauty and pleasure in art and literature, see Wendy Steiner, *Venus in Exile: The Rejection of Beauty in Twentieth-Century Art* (Chicago: University of Chicago Press, 2001).

14. In *The Lost Carving,* Esterly describes the visceral pleasure, intellectual stimulation, and even moral satisfaction derived from carving wood, and from trying to understand the techniques and choices of earlier artists. He calls wood carving "the repository of everything scorned by contemporary art, of beauty, skill, nature, feeling, tradition, sincerity, this throwback, this lost cause so hopeless at odds with the present age" (27).

15. Dennis Dutton, *The Art Instinct: Beauty, Pleasure, and Human Evolution* (New York: Bloomsbury Press, 2009), 52–59.

16. For an outline of these and other understandings of simulacrum, see Michael Camille, "Simulacrum," in *Critical Terms for Art History*, ed. Robert S. Nelson and Richard Schiff (Chicago: University of Chicago Press, 1996), 31–43.

17. This interpretation of Bidou's work follows the ideas of "nonwestern" models of representation as "virtual reality" in Noh and Russian icon painting, advanced by Theodore Botz-Bornstein in "Space in Noh-Plays and Icons," *Aesthetics and Politics of Spaces in Russia and Japan: A Comparative Philosophical Study* (Lanham, Md.: Lexington Books, 2009).

18. See note 2.

19. Jean-Michel Ribettes and Atsushi Miura, *Les 100 Sourires de Mona Lisa* (Tokyo: Nihon keizai shinbun, 2000). The exhibition was paralleled by the Fuji Television program *Mona Lisa no hohoemi* (The Smile of Mona Lisa).

20. This discussion of Barthes's explanation of appropriation is found in Robert Nelson, "Appropriation," in *Critical Terms for Art History,* ed. Nelson and Schiff, 119–20.

21. Roland Barthes, "That Old Thing," *The Responsibility of Forms: Critical Essays on Music, Art, and Representation* (New York: Hill and Wang, 1985), 202.

22. Nelson, "Appropriation," 119.

23. See Rachel M. Payne, "Noh Masks on Stage and in Museums: Approaches to the Contextualization and Conservation of the Pitt Rivers Museum Noh Mask Collection," in *Making Japanese Heritage*, ed. Rupert A. Cox and Christoph Brumann (London: Routledge, 2010), 78–91.

24. Richard Brilliant, *Portraiture* (Cambridge, Mass.: Harvard University Press, 1991), 7. This definition adapts Hans-Georg Gadamer's emphasis on the artist's intention of portrayal.

25. Brilliant, *Portraiture*, 49.

26. Japanese traditions of portraiture vary greatly in degrees of idealization and naturalism based on the status of the subject and the function of the work. For an introduction to issues in Japanese portraiture, see Quitman E. Phillips, "Portraiture," *The Practices of Painting in Japan: 1475–1500* (Stanford, Calif.: Stanford University Press, 2000). For the relation to earlier portrait sculptures and even actual persons, see chap. 6, "The Form and Function of the Mask," in Marvin, *Heaven Has a Face, So Does Hell.*

27. Brilliant, *Portraiture,* 12–15. Lorne Campbell expands the meaning of portrait and portraiture to include pictures of actual people and religious figures, given the definition of those words in French. See Campbell, *Renaissance Portraits: European Portrait-Painting in the 14th, 15th, and 16th Centuries* (New Haven, Conn.: Yale University Press, 1990), 1.

28. Gadamer's position is outlined in Brilliant, *Portraiture,* 18.

29. Mark Nearman, "Behind the Mask of Nō," in *Nō/Kyōgen Masks and Performance,* ed. Teele, 21.

30. Brilliant, *Portraiture*, 112–15.

31. Francisco Calvo Serraller, "The Spirit Behind the Mask," in *The Mirror & the Mask: Portraiture in the Age of Picasso*, ed. Paloma Alarcó and Malcolm Warner (New Haven, Conn.: Yale University Press, 2007), 5. The work of French artist Orlon (b. 1947) demonstrates the mutable nature of the face.

32. John Klein, "The Mask as Image and Strategy," in *The Mirror & the Mask,* ed. Alarcó and Warner, 26–29.

33. Charles Shiro Inouye, *Evanescence and Form: An Introduction to Japanese Culture* (New York: Palgrave Macmillan, 2008), 66.

34. Serraller, "The Sprit Behind the Mask," 6–9.

35. Marvin, *Heaven Has a Face, So Does Hell,* 80–84. In these respects, Noh masks recall the psychological import of Greek death masks that, in some analyses, form the basis of European portraiture.

36. Eugene O'Neill, "Memoranda on Masks," *American Spectator,* November 1932, 3; cited in Margaret Coldiron, *Trance and Transformation of the Actor in Japanese Noh and Balinese Masked Dance-Drama* (Lewiston, N.Y.: Edwin Mellen Press, 2004), 5. At the Théâtre du Vieux-Colombier, Jacques Copeau created neutral masks based on Ko-Omote to force actors to act with the whole body, not just the face.

37. Sōetsu Yanagi, *The Unknown Craftsman: A Japanese Insight into Beauty,* adapted by Bernard Leach (Tokyo: Kodansha International, 1972), 164–65.

38. Shin'ichi Hisamatsu, *Zen and the Fine Arts,* trans. Gishin Tokiwa (Tokyo: Kodansha International, 1971), 100–01. Hisamatsu goes so far as to say that the pose of Sakyamuni in Liang Kai's painting *Sakyamuni Descending the Mountain* "is the basis of all the poses in the Nō drama" (62). For a more refined study of Noh and Buddhism, see Royall Tyler, "'The Path of My Mountain': Buddhism in Nō," in *Flowing Traces: Buddhism in the Literary and Visual Arts of Japan*, ed. James H. Sanford, William R. LaFleur, and Masatoshi Nagatomi (Princeton, N.J.: Princeton University Press, 1992), 149–79.

39. Kishō Kurokawa, *Intercultural Architecture: The Philosophy of Symbiosis* (Washington, D.C.: American Institute of Architects Press, 1991), 78. The book illustrates several Noh masks.

40. Midcentury followers of Kōgyo include the obscure Hanabusa Hideki, Matsuno Hideyo, Matsuno Sōfū, and Yamaguchi Ryōshū.

41. Fumiko Enchi, *Masks,* trans. Juliet Winters Carpenter (New York: Knopf, 1983). A less positive assessment of Noh masks—and Japanese society—appears in Kōbō Abe's novel *Tanin no kao* (The Face of Another), published in 1959.

42. For Sakamoto's art and life, see Ishibashi Museum of Art, *Sakamoto Hanjirō* (Kurume: Ishibashi Foundation, 2006).

43. Awazu's *Noh Performance at UCLA* (1981) fills the poster with a female mask, giving it a status like that of *Mona Lisa,* used for his poster for the Sogetsu Art Center's 1968 symposium "Ex'pose '68: Say Something, I'm Trying." Yokoo's poster *Yume no ukihashi (Floating Bridge of Dreams),* created for the National Noh Theatre in 2000, presents three Noh masks against a cacophony of motifs from old paintings of the *emaki* genre. Tanaka's posters are published in Gian Carlo Calza, *Tanaka Ikko: Graphic Master* (London: Phaidon, 1997), 136–43.

44. Although well removed from Rose's phantasms and overt Noh mask imagery, the work of video artist Bill Viola also connects with Noh, though indirectly, through its glacial pace, an aesthetics of bafflement, and themes that focus on the weight of being human. In an interview with Mel Cooper on July 10, 2003, Viola remarked, "In 1980 I went to Japan as a video artist to study Zen paintings and the 600-year-old traditional Noh Theatre. It seemed off the wall or arcane at the time, but I never could have developed the concepts and techniques I now have about time and slow motion without knowledge of Zen and Noh drama." Frederico Utrera, *Viola on Vídeo* (Las Palmas: Universidad de las Palmas de Gran Canaria, 2011), 387.

45. Work from the series is published in David Elliot, *Bye-Bye Kitty!!!: Between Heaven and Hell in Contemporary Japanese Art* (New York: Japan Society; New Haven, Conn.: Yale University Press, 2011).

46. Simon Starling, *Project for a Masquerade (Hiroshima)* (Hiroshima: Hiroshima City Museum of Contemporary Art, 2011).

47. Inouye, *Evanescence and Form,* 65.

48. Inouye, *Evanescence and Form,* 66.

49. S. N. Eisenstadt, *Japanese Civilization: A Comparative View* (Chicago: University of Chicago Press, 1996), 386. The intertextuality of Noh recalls Roland Barthes's definition of texts as "multi-dimensional spaces" that blend and clash. See Barthes, "The Death of the Author," *Image, Music, Text*, trans. Stephen Heath (New York: Hill and Wang, 1977), 146.

50. Konparu Zenchiku, quoted in *Nō/Kyōgen Masks and Performance,* ed. Teele, 43.

51. Etsuko Terasaki, *Figures of Desire: Wordplay, Spirit Possession, Fantasy, Madness, and Mourning in Japanese Noh Plays* (Ann Arbor: Center for Japanese Studies, University of Michigan, 2002), 10–11.

52. See Edith Sarra, *Fictions of Femininity: Literary Inventions of Gender in Japanese Court Women's Memoirs* (Stanford, Calif.: Stanford University Press, 1999).

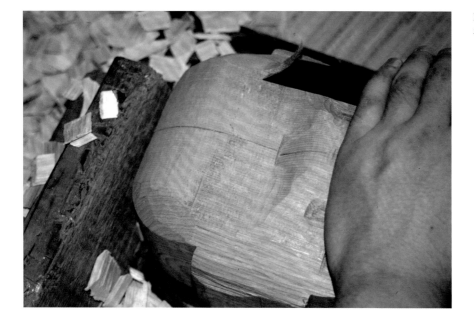

Rough carving of the mask's front

53. J. Thomas Rimer, *Modern Japanese Fiction and Its Traditions: An Introduction* (Princeton, N.J.: Princeton University Press, 1978), 121.

54. Terasaki, *Figures of Desire,* 9.

55. In response to questions from William T. Vollmann, Bidou said, "as a *nomenshi* I have always worked from a basis in *utsushi*. As I see it, whereas *monomane* consists in mere superficial copying, *utsushi* adds one's own spirit or soul to the physical likeness and thereby creates an aesthetic 'inner truth' that partakes of *yūgen*. It is more of a meditative act, similar to how Buddhists render calligraphic *utsushi* of the sutras *(shakyō)* as a spiritual discipline."

56. Bidou, interview with the author, New York, March 14, 2013.

57. Bidou's work recalls the lesson of the muses in Hesiod's *Theogony*; they tell the poet and his fellow mortals that, without art and history, man is but a belly; cited in Francine Prose, *The Lives of the Muses: Nine Women and the Artists They Inspired* (New York: HarperCollins, 2002), 3. William T. Vollmann explores this idea in the conclusion of *Kissing the Mask: Beauty, Understatement, and Femininity in Japanese Noh Theater* (New York: Ecco, 2010), 387–88. Bidou's art makes an intriguing parallel with Bill Viola's videos and video installations in terms of its Noh sensibility, reference to European Old Masters, exploration of human emotion, and embrace of the "weight of being."

58. Jane Bennett, cited in Anthony Julius, *Transgressions: The Offences of Art* (London: Thames & Hudson, 2002), 49.

59. See Terasaki, *Figures of Desire,* 13–15. Terasaki (15–18) also applies to Noh Paul de Man's ideas on prosopopoeia (as ghost) and anthropomorphism (as reincarnation), with fascinating implication for Noh masks and Bidou's art, particularly as de Man translates prosopopoeia as "face" and a "speaking face," "implying that a face is the condition of the existence of a person" (18).

Rough carving of the mask's back, or inside

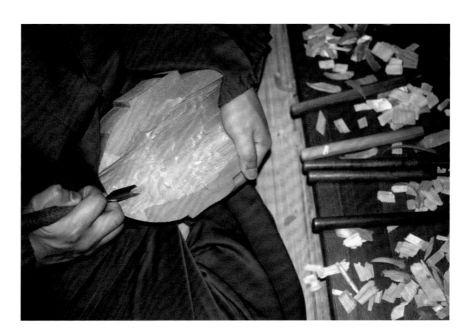

# NOH AS TOTAL THEATER

J. Thomas Rimer

"The mask is most important *always,*" the great Noh actor Umewaka Rokurō (b. 1948) once told William T. Vollmann.[1] The mask [cats. 1, 2] indeed does represent a supreme element in Noh performance, as Vollmann points out in his essay in this volume. Still, Noh is a multifaceted art, and its spectators have also focused on many other aspects of its centuries-long tradition. There are therefore several avenues for discussing this complex and beautiful Japanese theatrical entertainment.

What is Noh? The kanji, or Chinese character, for this term means something like "talent" or "skill," and in this case it identifies a kind of "total theater" that integrates dance, song, declamation, text, and costume into a unique form of performance. There are three components that, working in close relationship with one another, seem to me to define the shifting parameters of this classical theatrical form over its long history. They make a triangle, as follows:

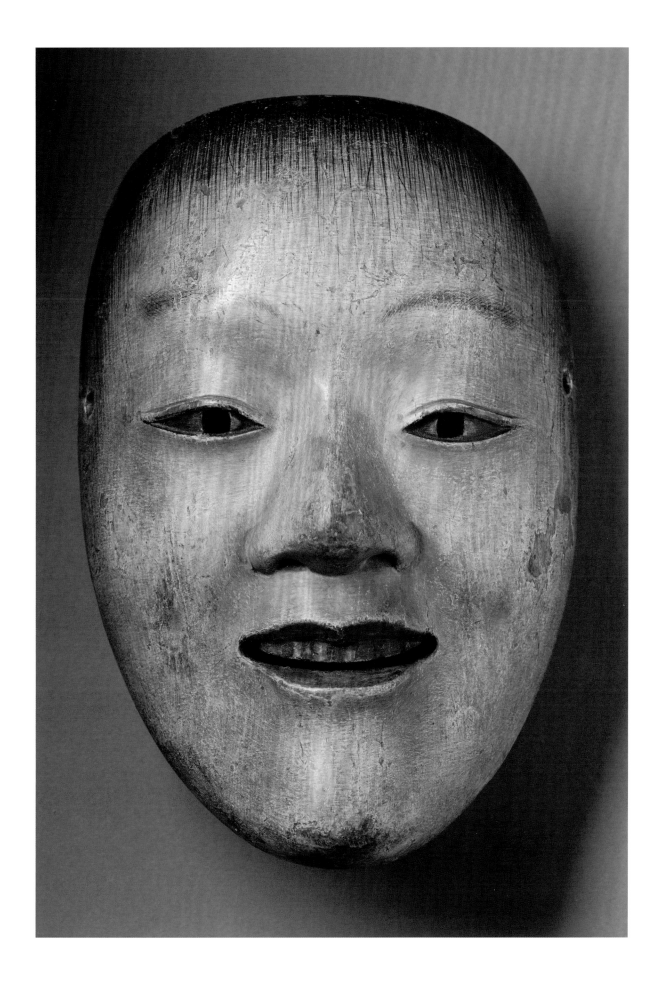

As each part in this complex interrelationship of theatrical elements shifts, the nature of Noh itself becomes subtly altered as well. Those who see a Noh play in the twenty-first century are experiencing one of the oldest performing arts traditions in the world, one that goes back well before the time of the great actor, playwright, and aesthetician of Noh, Zeami Motokiyo (1363–1443)—generally considered to be the figure who first and best defined its nature and artistic potential. Yet then, as now, this art is intimately tied to the preferences of its spectators. As Zeami expresses in one of his treatises on the subject, "As our art is based on the desires of our audience, successful performances depend on the changing tastes of each generation."[2]

One can, of course—as I will here—attempt to describe the general nature of Noh theater, but any such explanation is perforce an intellectual process and can only convey the mechanics, not the emotional boundaries, of an actual performance. Indeed, if one were to choose a western art form that is closest to Noh in terms of structure, it would probably be opera, which also includes multiple performance elements. Yet, in concrete terms, opera—with its overt emotions and often flamboyant stage movement—far more resembles Kabuki, another form of popular Japanese traditional theater that emerged some centuries later than Noh. To continue the musical analogy, Noh—to today's spectator, at least—is closer in terms of scope, focus, and intensity to a string quartet or a lieder recital.

One of the best means to learn of the ways in which Noh has defined itself over the centuries is to look at the plays and writings of Zeami, who, along with his father, Kan'ami (1333–1384), changed Noh from a kind of popular entertainment to a form of theater suitable for the sensibilities of a highly educated nobility. From Zeami's moment in time, one can look back at Noh's popular beginnings and also look forward to its later vicissitudes and developments. There is no better place to begin.

Zeami's writings on Noh are basically private documents, meant to instruct his descendants in the art of acting, and as such they are among the most remarkable texts of their kind. They include a description of the elements that make up a well-crafted Noh play, conjuring up a dramatic performance tradition that can still easily be recognized by anyone attending a Noh performance. He laid down the great lines that still come together to define this art.

In the course of his writings, Zeami explains the interlocking elements that make up the totality of the artistic functions involved in Noh performance. The triangular relationship mentioned above thus suggests the kind of mutual relationships that, together, can create a theatrical and poetic world that is "in alignment with such universals as the ephemerality of life and the power of beauty," as Vollmann puts it.[3]

## 1. THE WORK ITSELF

To today's spectator, the appearance of the Noh stage is invariably minimalist [cat. 3]. Noh uses no scenery (but does have beautiful props), and the actors appear on an elegant flat performance space that is about 19' x 19'. Behind them, painted on a wooden wall, is a felicitous pine tree, the sole décor in use. A walkway connects to the rear left of the stage, making a bridge to the curtain of the "mirror room" *(kagami no ma),* where the actors prepare for their entrances and the *shite* (literally, "the one who does") puts on his mask. This walkway provides a powerful location for entrances and exits.

Cat. 2

Tsukioka Kōgyo

*Pictures of Noh Plays: Masks (Nōgaku zue),* 1902

Ink and pigment on paper

8.88 x 12.94 in.

Gift of Mrs. Frederick S. Bailey
Collection of Scripps College,
Claremont, CA

Cat. 3

Tsukioka Kōgyo

*Pictures of Noh Plays: Picture of Noh Stage (Nōgaku zue: Nōbutai zu),* 1898

Ink and pigment on paper

9.06 x 13.94 in.

Gift of Miss Lilian Miller
Collection of Scripps College,
Claremont, CA

Cat. 4

Tsukioka Kōgyo

*One Hundred Noh Plays: Okina
(Nōgaku hyakuban: Okina shiki),*
1923

Ink and pigment on paper

10.13 x 15 in.

The Aoki Endowment for Japanese
Arts and Cultures
Collection of Scripps College,
Claremont, CA

The performers [cat. 4], usually clothed in elegant costumes, are male (as in Shakespeare's theater), no matter what roles they play. As in opera, they are divided into categories. In the case of opera, the distinction is usually made in terms of voice range (such as soprano, tenor, or bass), but in Noh, the divisions are determined by the type of role performed. The *shite*, the main character in the drama, is generally the only performer to wear a mask. The subsidiary characters are usually termed *waki* (literally, "to the side") or *tsure*, "the one who accompanies," and like the *shite*, have their own training and performance traditions. In addition, Kyōgen actors play smaller roles and present comic interludes between the Noh plays. A chorus, sitting at stage left, comments and occasionally participates in the action, and a small ensemble of instrumentalists, seated at the rear, play the flute and drums.

What sorts of dramas do these performers present? A wide variety of plays have been written over the centuries, and the canon now contains some two hundred plays, including a number of masterpieces by Zeami that are frequently performed. Some works have fallen out of the repertory and are revived from time to time. Occasionally, new plays are written and performed. In this aspect of Noh, too, there is a resemblance to the performance traditions of opera.

In terms of tone, the plays vary from the solemn to the intense. In terms of subject matter, they traverse an emotional terrain that ranges from thwarted love and Buddhist renunciation to the loss of one's children, madness, and demonic possession.

For many westerners with an interest in Noh, the texts of the plays constitute their chief appeal. Up until a little more than a hundred years ago, Japan was closed off from foreign contact. When western visitors to Japan in the late nineteenth century began to explore Japanese culture, many of them became fascinated with Noh. European observers often judged Noh to be the Japanese equivalent of the classic theater traditions of Greece, England, and France, and it is not surprising that some of the earliest translations of classical Japanese literature consisted of English and French versions of these extraordinary poetic texts. Ernest Fenollosa (1853–1908), who traveled to Japan to teach philosophy and went on to become an important art historian, studied the art of

Noh performance; his translations of plays were later revised and published by the poet Ezra Pound (1885–1972). Marie Stopes (1880–1958), well known for her advocacy of birth control, lived in Japan in the early years of the twentieth century; intrigued by Noh, she published a book of play translations in 1913. Perhaps the most widely read and admired translations were those published in 1921 by the great scholar Arthur Waley (1889–1966). These various efforts introduced Noh to the West, seemingly defining it as a refined literary art, and indeed, the plays as poetic dramas certainly stand high in the ranks of the world's dramatic literature.

Yet, in the minds of Noh performers and Japanese spectators alike, these play texts function much more like opera librettos; they serve as part of the whole theatrical experience and are not an end in themselves. In the traditional Japanese view, these plays were constructed to provide maximum opportunity for successful performance. Zeami, himself surely the supreme composer of these texts, makes a number of points in his treatises about how to construct a successful play. Perhaps chief among them is the idea that a play should be based on a source *that the audience can recognize*. In other words, recognition, not novelty for its own sake (certainly the hallmark of modern drama around the world), always remains the keynote. The themes that Zeami chose to dramatize for the educated nobility were familiar to them from legends and literary classics. For the larger crowds who thronged to see Noh performances at shrines and festivals during Zeami's time and after, the subjects of such plays provided something of an introduction, even to the unlettered, to the riches of Japanese high culture, supplying what William T. Vollmann so aptly characterizes in his essay as a "near-infinitude of allusive richness."

Today, of course, audiences must learn to recognize what was once familiar—characters from legend, classic texts such as *The Tale of Genji* and *The Tale of the Heike*, and the work of such famous poets as Saigyō (1118–1190) and Fujiwara Teika (1162–1241). To grasp and understand the range of Noh subject matter is to know the scope of classical Japanese culture, geography, and literature.

Auditory recognition of the text can also be difficult for today's theatergoers, since the archaic grammar and vocabulary used in the plays makes the dialogue virtually unintelligible to the untrained. It is common to see members of the audience in Japan following the performance with a printed text in their hands, so as to better understand the general meaning of what the actors are declaiming.

Much has been written about the emotional states that these plays are intended to evoke. Although Noh is never realistic in the sense of modern drama, nevertheless—within the general aesthetics of the genre—there exists quite a wide range of dramatic possibilities, depending on the characters and situations to be portrayed. Not all plays share the same level of profundity, of course. For Zeami, the characteristic impression to be kindled in the emotions of the audience is what he terms *yūgen*, a term notoriously difficult to translate. It is sometimes rendered as a sense of "mystery and depth," an ineffable emotional understanding of mutability and sadness that comes from a deep awareness of the human condition. Zeami defines it poetically: "Cannot the beauty of *yūgen* be compared to the image of a swan holding a flower in its bill, I wonder?"[4] Vollmann's lengthy discussion of the term in his essay shows by multiple examples the range and power of its fluidity and ambiguous beauty.

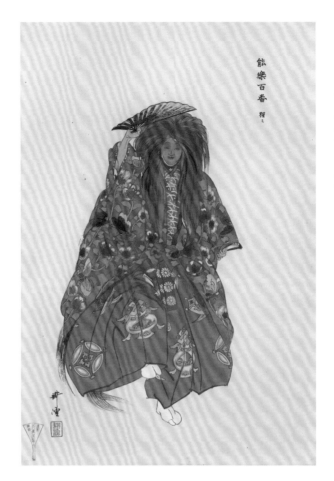

## 2. THE ARTIST

Clearly, then, these Noh texts—however beautiful—were created to be performed. To do so, particularly for the *shite,* requires physical and emotional control and a mastery of appropriate dancing and singing techniques. Actors who possess such expertise have been and still are great stars in their own right, and continue to have their own enthusiastic followers.

Zeami provides fascinating insights into how these various elements must be combined in order to create an effective performance. His observations are strikingly practical and precise. With regard to the relation between word and gesture, for example, he remarks that "the audience should first hear the chant, then see the appropriate gesture afterwards, so that when they see what they have already understood, the satisfying sensation of a genuine union between the two images will be created in the moment of transition from one to the other."[5] The level of training and commitment required to become a superior *shite* performer is such that a lifetime of dedication is required to hone the necessary skills.

Along with dancing, a good deal of singing in various styles is involved in any given Noh performance. It has been my observation, in taking friends and visitors to see Noh over the years, that the music is the most difficult aspect of the performance for westerners to appreciate. The modalities and the range of vocal techniques employed are both so different from those used in western musical traditions that the effect can be bewildering for a neophyte. However, this musical underpinning helps underscore the emotional subtext of the performance and provides a basic rhythmic pulse as

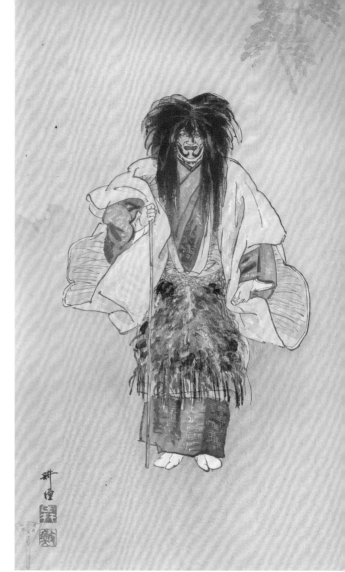

Cat. 8                                                Cat. 7

the invariable sequencing of the play progresses. In Japanese Noh terminology, this forward movement is broken down into three sections that span the duration of the performance—*jo, ha,* and *kyū*, which might be translated roughly as introduction, development, and fast finale. As the performance goes on, the music becomes ever more intense until a final climax, dramatically and musically speaking, is reached, with the music sometimes trailing away at the very end.[6]

However successful the performer may be in exhibiting various dramatic and musical skills, Zeami is quick to point out, he must always put his talents at the service of the material he performs and never seek to merely attract attention to his own abilities. Dedication is all.

## 3. The Patron

Finally, there is the patron. The shifting nature of patronage, the source of Noh's fundamental financial support, has continued to affect the development of the form in significant ways over the centuries. Though Noh was originally presented by traveling troupes to popular, unlettered audiences, its performance and literary paradigms shifted, as noted above, with the transformations brought about by Zeami. In this regard, aristocratic patronage was crucial.

CAT. 8

BIDOU YAMAGUCHI

*Yase-otoko (Emaciated Man)*, 2003

Japanese cypress, seashell,
natural pigment, lacquer

9.25 x 5.98 x 3.27 in.

Collection of Kelly Sutherlin McLeod and
Steve McLeod

CAT. 7

TSUKIOKA KŌGYO

*One Hundred Noh Plays: Birds of
Sorrow (Nōgaku hyakuban: Utō)*
1925–1928

Ink and pigment on paper

15 x 10.13 in.

The Aoki Endowment for Japanese
Arts and Cultures
Collection of Scripps College,
Claremont, CA

One early work that was developed long before Zeami's time suggests
the nature of Noh in its earliest, pre-literary phase. *Okina* (also the name of the play's
elderly character [cat. 4]) is basically a group of dances, performed in order to seek the
help of the Shinto gods as a means to peace and prosperity. The dramatic elements are
virtually undeveloped.

When Zeami was working as a boy actor, the performances of his father's
troupe were seen by the shogun Ashikaga Yoshimitsu (1358–1408), who was so
impressed that he provided subsidies to the troupe and arranged for Zeami to receive
a proper education. This shift in fortune, turning Zeami into an artist and intellectual,
completely shifted the horizons of Noh. And while the popular audience at the time
did not disappear, performers began to attune their skills in an attempt to satisfy a new
and highly educated audience. The dramas of Zeami and playwrights from succeeding
generations reveal a remarkable refinement in emotional nuance and philosophical
profundity seldom found in the few textual examples that remain from the period before
Zeami's generation.

Earlier, troupes were usually supported by temples and shrines that employed
performers to act out local stories and legends. Beginning with the patronage of Ashikaga
Yoshimitsu, however, the troupes in the various schools of performance were supported
by the Ashikaga shogunate or by powerful local lords.[7] This form of patronage remained
the norm until 1600, when political power in Japan was consolidated by the Tokugawa
shogunate. Noh became analogous to a court theater in Europe—available only to the
upper classes. Other than occasional charity performances for a larger public, Noh as
a performance art disappeared from general view, although some of the Noh repertory
remained familiar through adaptations in Kabuki and *Bunraku* (puppet) performances that
continued to enjoy wide circulation.

In 1868, when the Tokugawa shogunate was dissolved and the centralized Meiji
government was installed, Noh lost its major patrons. For a certain period of time there
was a fear that this long-lived performance tradition might disappear altogether. The
story of how a new audience was created and how suitable new patronage was achieved
and sustained for this now venerable art is a fascinating one. Certain details of this virtual
resurrection are still the subject of considerable scholarly investigation in Japan.[8]

One of the ways in which Noh received wider publicity was through the
circulation of woodblock prints illustrating the plays and their performers, as well as
costumes, props, and other aspects of Noh. Among the printmakers of this period, the
most gifted and successful was Tsukioka Kōgyo (1869–1927), the adopted son of the
celebrated printmaker Tsukioka Yoshitoshi (1839–1892). A number of Kōgyo's prints have
been chosen to illustrate this essay. Over the course of twenty years or so, he created a
large number of prints that cover a significant portion of the Noh canon, and these works
now serve not only to illustrate the beauties of Noh performance but also to suggest
something of the evolving performance traditions that the artist witnessed.

Several of Kōgyo's prints of individual *shite* roles and the masks worn in
performance are illustrated in the present catalogue. The drama *Shōjō* (The Drunken
Imp; cats. 5, 6), author unknown, is set in ancient China; a sprite dances, then gives his
patron a well of wine that never runs dry. *Utō* (Birds of Sorrow; cats. 7, 8), attributed to
Zeami, examines the intense chagrin of a hunter who has needlessly killed such birds,
disregarding the Buddhist precept of the sanctity of all life. *Hagoromo* (The Feather
Mantle; cats. 9, 10), sometimes attributed to Zeami, concerns an angel who dances in
order to obtain her robe from the fishermen who found it on the branch of a pine tree.

One constant among devotees of Noh from Zeami's time to the present has been an interest in amateur participation in professional performances. There are numerous examples of amateur role-playing by members of the upper classes. Indeed, Toyotomi Hideyoshi (1536–1598), the famous warrior and general who did so much to alter the course of Japanese history, had plays written especially for him, and he rejoiced in performing the part of the *shite*. With the democratization of Noh in the Meiji period and after, a wide variety of amateurs enjoyed learning to sing and chant important passages from many of the great plays, in a fashion somewhat analogous to students taking piano lessons to try to perform a bit of Beethoven and Mozart on their own. Such enthusiasts now comprise a certain segment of today's audiences. Some of them are women, and indeed, some female performers have become so adept that they have occasionally participated in professional performances. In all such cases, the fees paid by amateurs for lessons have provided a real source of income for professional troupes.

Probably the most important boost to the recent patronage of Noh came in 1983 when the National Noh Theatre was opened in Tokyo, thanks to government subsidies. Such patronage now helps ensure the financial future of what remains a labor-intensive and increasingly expensive classical art.

Finally, one might raise the question of the status of Noh in the larger world of the theater, both now and in the future. From the point of view of the casual foreign observer, it often appears that Noh is static, an art that remains resistant to change. But, as I have indicated, this has never been true. Over the centuries, audiences have sought differing pleasures from Noh performances. Research has indicated, for example, that performances have become much slower and more stately since the patronage of Noh by many daimyo at the time of the Tokugawa shogunate. Performances originally experienced outdoors in daylight and in temporary performance spaces are now most often viewed inside, under strong electric lighting. And of course, the various troupes active today (most date back to Zeami's time and before) perform any given play in slightly differing styles, as comparative photographs make clear.

In the postwar years, new Noh plays have been occasionally commissioned, and some have been performed with considerable success, often under the sponsorship of the National Noh Theatre. Some, like the play first presented in 2000, *Yume no ukihashi* (The Bridge of Dreams), are based on Japanese classics (in this case, *The Tale of Genji*). Others are altogether new creations, such as the 1991 *Mumyō no i* (The Well of Ignorance), which deals with the issue of heart transplants. Indeed, some of the Noh-style plays written by western enthusiasts have been translated into Japanese and performed by Noh actors, notably works by William Butler Yeats (1865–1939).

More general experiments with certain elements of the Noh format have become increasingly visible in Japan. Perhaps the most celebrated examples are the so-called modern Noh plays of the novelist and dramatist Mishima Yukio (1925–1970). Mishima took the basic storylines of several famous Noh plays and recast them in modern situations to be performed by actors trained in realistic acting techniques. Other gifted playwrights, such as Kinoshita Junji (1914–2006), have borrowed elements of Noh structure in constructing such highly popular plays as his *Yūzuru* (The Evening Crane), with its plot lines taken from a Japanese folktale.

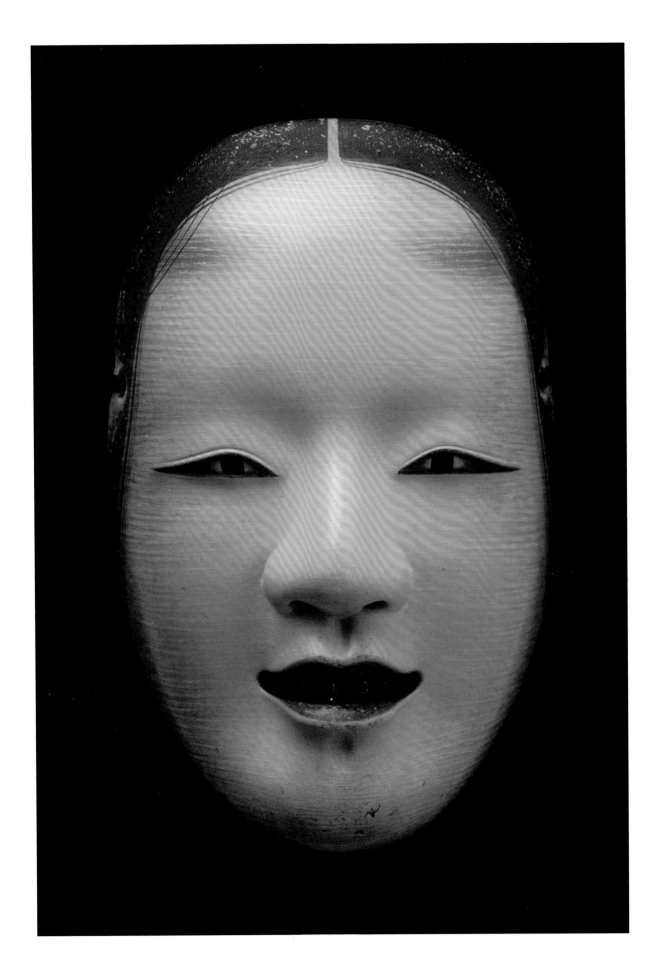

In recent decades, a number of celebrated Noh artists have also participated in other types of theatrical performances. Kanze Hisao (1925–1978), one of the greatest Noh actors of his generation, worked with the French director and actor Jean-Louis Barrault (1910–1994) and the avant-garde Japanese director Suzuki Tadashi (b. 1939). Such activities have connected Noh to larger currents in the best of modern performance.

Noh, or at least the example of Noh, has now become a force in world theater. True, much of this activity, until recently, has been concentrated on the literary rather than the performance aspects of Noh. Once translations of plays began to appear in western languages a hundred years or so ago, writers and directors began to make use of what they took to be the central elements of the Noh aesthetic. Beginning with the Noh plays of William Butler Yeats, such writers as Paul Claudel (1868–1955) and Bertolt Brecht (1898–1956) adapted devices from the tradition into their own dramaturgy, and directors such as Jerzy Grotowski (1933–1999), Peter Brook (b. 1925), and Robert Lepage (b. 1957), among many others, have used elements from Noh in their staging of a variety of important theatrical experiments.

Noh has now become established as an international phenomenon. It is within this fresh and exciting context that Bidou Yamaguchi creates his remarkable masks, which bear witness to the way in which a venerable tradition now embraces the world, and how the larger world, in turn, has come to revere this ancient Japanese performing art. When Vollmann writes in his essay that "the *yūgen* of these masks, like their originals, is deep," he is acknowledging a new phase in the long pilgrimage of Noh from the medieval period to the present, and now on into the future.

DETAIL OF CAT. 5

DETAIL OF CAT. 7

DETAIL OF CAT. 9

# NOTES

1. Emphasis is Umewaka's. See William T. Vollmann, *Kissing the Mask: Beauty, Understatement, and Femininity in Japanese Noh Theater* (New York: Ecco, 2010), 37.

2. See Zeami, "Style and the Flower," in *On the Art of the Nō Drama: The Major Treatises of Zeami*, trans. J. Thomas Rimer and Yamazaki Masakazu, Princeton Library of Asian Translations (Princeton, N.J.: Princeton University Press, 1984), 47.

3. See William T. Vollmann's essay in this volume, 43.

4. Zeami, "The True Path to the Flower," in *On the Art of the Nō Drama*, 73.

5. Zeami, "A Mirror Held to the Flower," in *On the Art of the Nō Drama*, 76.

6. For those who enjoy modern music, perhaps the best way to appreciate the cumulative power of the musical and dramatic elements in Noh performance is to witness a performance (or listen to a recording) of the remarkable one-act opera of Benjamin Britten, *Curlew River*, written after Britten's visit to Japan in 1956. His opera, a church parable, is based on the great Noh play *Sumidagawa* (The Sumida River). Here, the cumulative effect of the movement and music is overwhelming, since the Noh idiom is adapted to elements familiar from western culture. The chorus is a group of Christian monks, and the main characters are recast as figures in a medieval religious narrative. Many of the devices are the same (such as the all-male cast, the gradual intensification of the music, and the lack of a set), but the configuration seems strikingly fresh and moving. The effect of the original Noh performance can be equally profound, of course, but it takes more effort for an audience, particularly a western audience, to penetrate other traditions.

7. The schools of Noh that are active today (Kanze, Hōshō, Kongō, Komparu, and Kita) have slightly differing performance traditions, particularly as concerns the *shite* role.

8. For an assessment and specific references to some of these issues, see various entries in Robert Schaap and J. Thomas Rimer, *The Beauty of Silence: Japanese Nō & Nature Prints by Tsukioka Kōgyo 1869–1927* (Leiden and Boston: Hotei Publishing, 2010).

# "Made to be Ambiguous": The *Yūgen* of Noh Masks

William T. Vollmann

Cat. 11

Bidou Yamaguchi

*Mona Lisa*, 2003
(multiple views)

Japanese cypress, seashell,
natural pigment, lacquer

8.35 x 5.75 x 3.15 in.

Collection of Kelly Sutherlin McLeod
and Steve McLeod

**1.**

"A defining characteristic of the Noh mask is the way in which the emotion it expresses is made to be ambiguous. When it is put on, however, the theoretically static mask is able to express a wide range of feelings through various movements and the way its gaze is angled slightly up and down."[1] This introductory description will serve as well as any for an object that in its sleek-yet-pared-down elegance, its haunting loveliness (and sometimes also its grotesquerie), its long-lived homage to transience (the best Noh masks smile at a mere two or three centuries), its combination of stillness and motion, its conflation of human, divine, and monstrous, sometimes deserves the name "great art."

Although Noh masks, costumes, or texts (the "librettos"), or even Noh chanting, may be appreciated in isolation, of course they were intended to come alive in combination. The more we know about them all, the better we can appreciate them. And the Noh corpus itself, rarefied though it has become (many Japanese lack the patience to sit through a Noh performance), is but one production of a long-enduring, hence somewhat consistent Japanese cultural tradition. What do I mean by "somewhat consistent"? Needless to say, everything I write here is a shameful (and shameless)

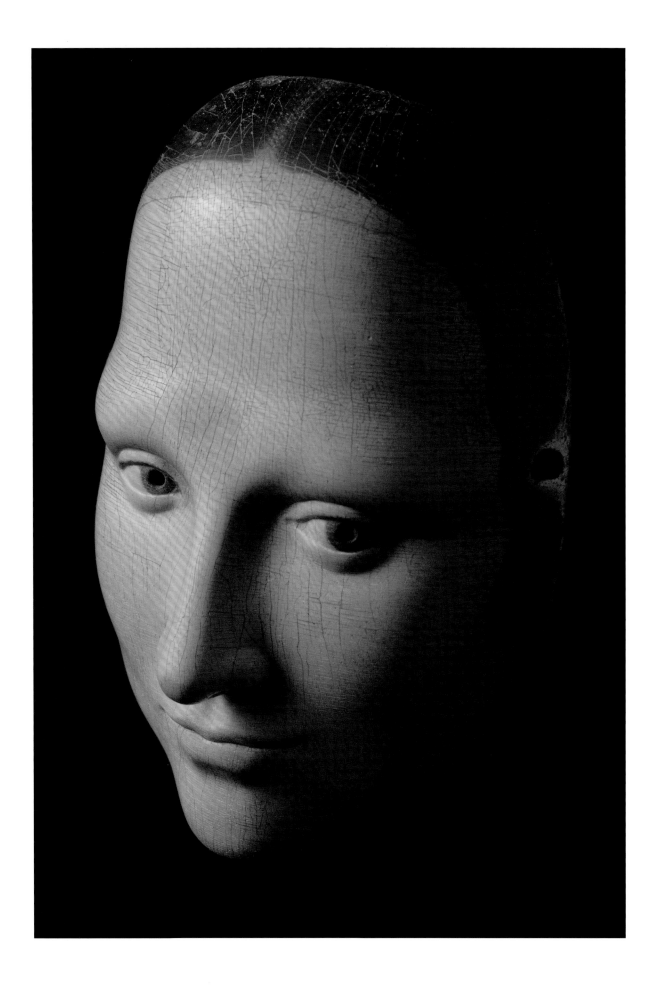

simplification. But rather than emulate the horrid example of Edward Casaubon in George Eliot's *Middlemarch*—he spends his whole life preparing to organize his great intellectual system, in other words, "to grow grey crunching bones in a cavern"[2]—I will lurch from error to vulgarity, and perhaps in the process hint at what a Noh play (or a classical poem, or a contemporary Kyoto geisha's kimono, dance, and hair ornament) may draw upon: allusions to the bygone capital, and to the plants, birds, and seasons thereof peculiar to Japan, and to thousand-year-old poems continually remembered and present in newer works; the imperial associations of vermilion, the erotic and youthful feminine connotations of red; Buddhist sutras, Shinto rites, ancient Chinese happenings—mixed in with the inevitable human flotsam of mummified witticisms, and with the political flattery by the dead for the dead. Perhaps if he had studied Japanese, our Mr. Casaubon (who would have applauded the Japanese premium on rote and discipline) could have kept track of all this. For those of us who have not, what we can take away from Noh is first of all a sense of its near-infinitude of allusive richness. As a system, it offers any number of gestural, sartorial, and textual signs. We do not have to know them to appreciate Noh, just as we need not be acquainted with the Bible to enjoy much of *Moby-Dick,* although whatever we learn can only increase our enjoyment of craftsmanship, never mind genius. Second, in its kinship with other Japanese aesthetic productions, Noh helps us to engage in, or at least sense the presence of, a very wise and ancient way of experiencing "the world" in alignment with such universals as the ephemerality of life and the power of beauty.

Among the perceptual education and stimulation offered by this constellation of Japanese art forms is the formulation, creation, and transmission of *yūgen.*

## 2.

*Yū* is dark or hazy, otherworldly or quiet. *Gen* is subtle, fundamental, deep or dark.

The *yūkon* are the spirits of the dead. *Yūshū* is deep contemplation.

*Genri* means esoteric truth. *Genshu* is profound beauty.[3]

What then is *yūgen?* Something chthonic, uncanny, subterranean—and thus inexplicable—and therefore perhaps none of the above, not uncanny at all but *beyond,* not perhaps beyond all description but certainly superior to my definitions; as usual, the best I can do is commit crimes of allusion. *Yūgen* is elegant, but not all elegance is *yūgen.*

A book on Japanese court poetry concludes that "the core of *yūgen* remained the ideal of an artistic effect both mysterious and ineffable, of a subtle, complex tone achieved by emphasizing the unspoken connotations of words and the implications of a poetic situation."[4]

Another volume remarks: "*Yūgen* is the quality of the highest realm of art, an absolute domain to which all forms point....There is *yūgen* in the sight of a tea master dipping water into a kettle with simple movements that have about them the lines of eternity."[5]

A mid-twentieth-century Noh commentator writes: "While perfecting the simple and pure aesthetic of *yūgen* by strenuous self-cultivation, the *yūgen* becomes profound, striking deep into the world of emptiness, as oxidized silver has a dull and elegant glow which is more beautiful than mere superficial gorgeousness."[6]

The commentator also writes (just in case all these flitterings and circlings are not disparate enough for you) that *yūgen* is "a representation of...the age of the Imperial Court" in about 1000 CE,[7] and "a profoundly introspective expression of emotion."[8]

You may have perceived by now that the very resistance of this aesthetic category to strict definition comprises some of its charm. No one agrees on what life is or should be, but that in no way impedes us from craving it. And the knowledge of a Mr. Casaubon cannot guarantee that you will feel it, for it achieves its effects upon our sensibilities as well as our minds.

If you wish to learn more about the *yūgen* of Noh generally (but not, alas, a great deal about the *yūgen* of Noh masks), I recommend one of the most cherished books in my personal library: the major treatises of Zeami Motokiyo (1363–1443),[9] one of whose two co-translators is Professor Rimer, whose essay appears in this volume. Zeami's writings, which frequently deal with the representation of the ineffable, may help inform your appreciation of Bidou Yamaguchi's achievement. (By the way, when I asked Bidou what he supposed Zeami might say about the creations in this catalogue, he replied by quoting that old master: "That which resides nowhere should be foremost.")

My sensations of *yūgen* when viewing certain Noh performances or geisha dances rank among the richest aesthetic pleasures I have ever known. The more I study what to look for, and the better I learn to see, the more likely I am to be rewarded with this experience. *Yūgen* declines to insist upon itself. When it shows itself, the feeling is slow, full, brief. No doubt I miss it more often than I perceive it—for as the ancient actors and mask-makers rise ever farther from us on their pillars of cremation-smoke, their influence grows more temporary, singular (even alien). Instead of transmitting some wavelength of the dominant ethos, they express a shade delimited by their own oldness, like some temple that negates today's light within its specific contours, so that the past remains framed in our sunshine but cool and dark. Thus the strange toothy smile in a fat-faced Bugaku mask of the Kitoku-Banko type, if it shows itself at all (probably in the glass case of some museum), can scarcely project its influence very far, except to the scholar or the dreamer; and in the tunnel shadows of Tokyo, following the red spearheads on the right-hand curve and reflecting their windows in each other, the white cars of the Chuo Driving School creep between Bugaku-less zones. In short, what survives centuries but accidents? Just like a colored shrine-inlay ruined by dry-rot—runneled, bleached— the formerly self-evident, having decayed into the picturesque, maintains existence in increasingly feeble shards.

Hence Noh theater, like Bugaku, would be "difficult" by now, in any event. But Noh's difficulty gets magnified by its uncompromising fidelity to itself (which some would call elitism). To spell out Noh, or *yūgen,* may be done, and brilliantly, but never for all time. Not even Zeami and his father, Kan'ami (1333–1384), were able to envision the various elaborations of Noh mask species. And with Bidou, who has departed from today's Noh categories, evidently not without compulsion and grief,[10] the elaboration continues; the masks (or sculptures, as he calls them) have grown syncretic, partly un-Japanese, and for that matter less masklike.[11]

Their *yūgen* remains.

## 3.

Once upon a time, Francesco del Giocondo's spouse, who may or may not have existed as we know her, half-smiled, either "for real" or in the mind's eye of Leonardo da Vinci. Her portrait has been called "assuredly the subtlest homage that genius has ever paid to a once living face."[12] To see her in her rich dark dress, with her yellow-golden hands clasped, the top of her cleavage discreetly introducing itself, and her long dark hair framing her slender neck as she watches us gently and warily, or perhaps merely submissively, smiling without a smile in her eyes, neutral, near immortal, unknowable yet familiar (since she

has long embellished our own tradition), is to wonder who she is and where can be that dark-and-gold unfinished landscape behind her, something between an Italian summer twilight and the two-dimensional realm upon the face of a Byzantine icon. Is she happy or not? As a certain translator of Zeami's *Kadensho* remarks, "the subtle and mysterious expression of a Noh mask reveals an extreme repression of joy and sorrow."[13] This ambiguous glance of hers, why not call it *yūgen*?

Bidou's *Mona Lisa* offers the same faint smile as its two-dimensional exemplar, although her famous lips seem paler than I recall (no doubt my memory is at fault). Her nose, like that of the Tsuki, or "moon" variety, of young female Noh masks, tilts to the left, as does the original's. Again I study her sad, sweet, or merely intimate eyes, about which, thank goodness, I reach no conclusions. Then, thanks to Bidou, I take my strange opportunity to actually see her lips change at any angle.

I lower my head, and her pale pink lips compress; she seems to be looking to her left. Even though her smile has gone, and she is more abstracted, she also appears, at least to me, more certainly happy; she might be thinking of someone, or watching her secret lover slip into the crowded ballroom where she stands at her husband's side.

From above she seems to gaze still leftwards but more straight ahead and down than before; her crackled face is serenely yellowish, the lovely parting of her hair very reddish-brown and yellow; I wonder if her lovely golden eyelashes are chisel-strokes.

Later the afternoon light decorates the side of her face; a mercuric globule of shadow inhabits the temple and the hollow of her left cheek, while the sunshine comes to resemble a puddle of molten metal on her other cheek and the bridge of her nose.

## 4.

It is peculiar to see her without her body, but still more so without her long hair, like a conventional female Noh mask, although she does now have a ribbonlike zone of black-inked hair ascending from her temples, over-lining her forehead, parted in a straight and perfect channel. While she remains feminine, in comparison to her original she has grown a trifle androgynous. Zeami, always aiming for a balanced neutrality, advises each actor to soften a strong Noh role and strengthen an elegant one, which he will not be able to do "as long as he thinks that the elegance and power of the production are separate from the subject."[14] Bidou's *Mona Lisa* may well bear out this assertion. Her elegant femininity is, in Noh terms, strengthened or compensated for—that is, masculinized—so that her gaze and smile, partially detached from corporeality, become more intellectualized or spiritualized. When we think of Mona Lisa we think of her smile. Well, there it is, without breasts or hands. We can ponder it for itself; it is isolated, like the moon in a haiku.

## 5.

I am informed that Bidou uses the word *utsushi*, meaning "to copy, to reproduce," as "his term for all his work."[15] A dictionary of Japanese art terms reads: "It is said that Noh mask carving is referred to with the verb *utsu* (strike) because the art of making Noh masks requires the same intensely concentrated state of mind as that required in *katana-uchi* (sword-making)."[16] What this concentration entails cannot be known to us who were never apprenticed to sword-makers or Noh actors, and who for that matter would find difficulty in navigating between Wood Pond Road, Ghost Earth Road, and Dark Cave Road.[17] My interviews with geisha dancers have persuaded me that the strict or sometimes even cruel drills through which they are trained (ideally[18] from young childhood) enable them to achieve a near-perfection of exact copying of certain stylized

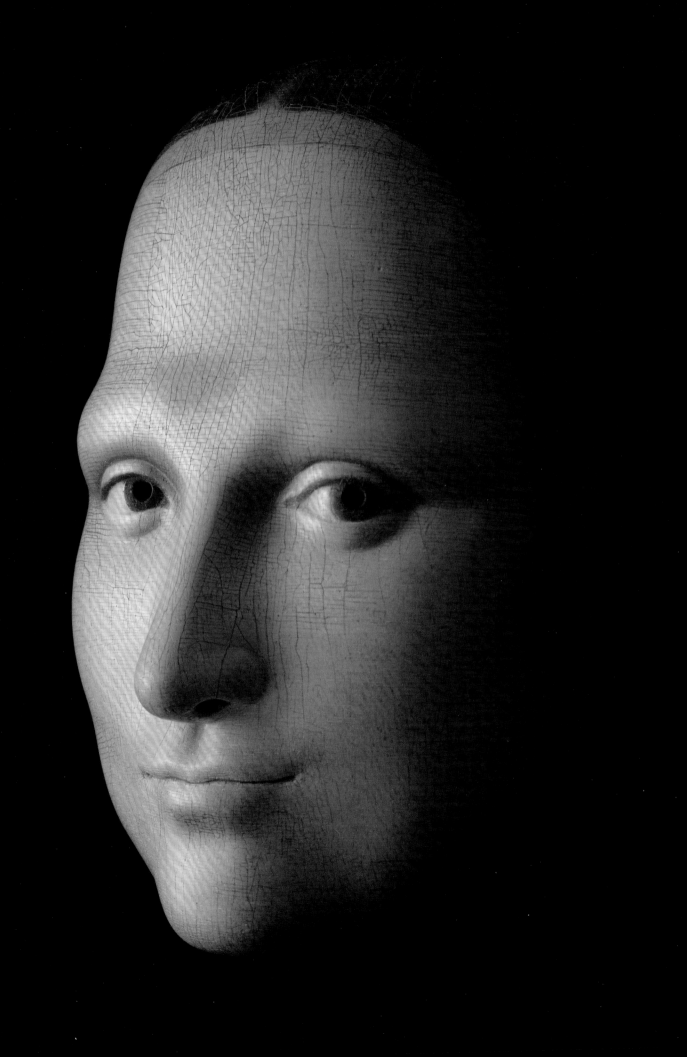

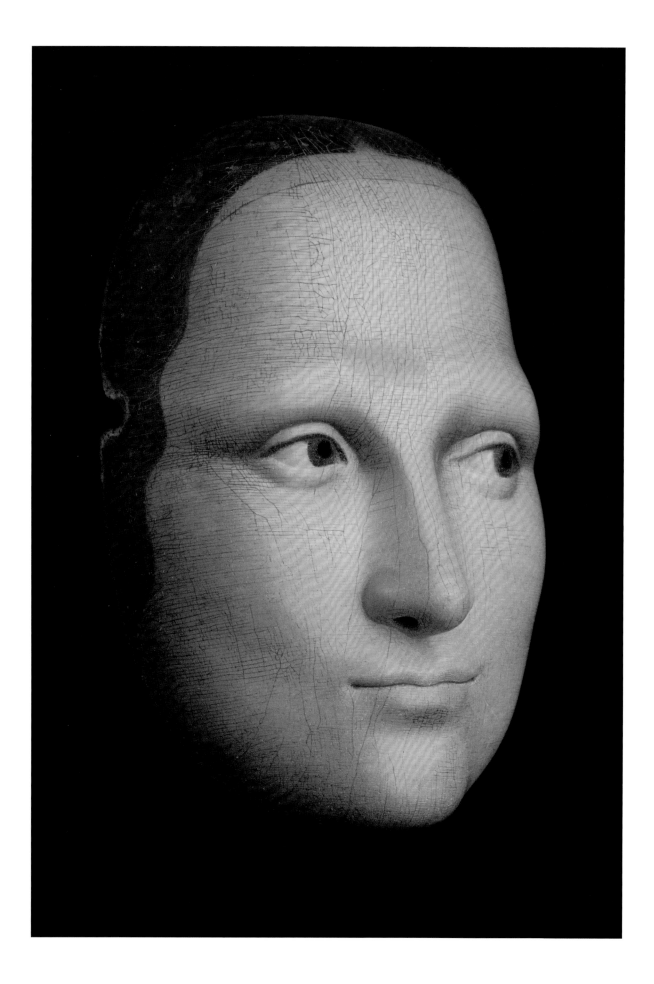

gestures; and through this copying they come to express themselves. As Zeami explains, "When every technique of Role Playing is mastered and the actor has truly become the subject of his impersonation, then the reason for the desire to imitate can no longer exist."[19] (Plato: "The actor's mask becomes his face.") Thus the movements, like the career itself, become inevitable. Zeami sometimes remarks that "there is no room for my own thinking," or that "one must strictly avoid the tendency for self-assertion." A geisha musician named Danyu-san, whose parents apprenticed her when she was very small, said to me, "They make it so that the child realizes she cannot do anything else."[20]

It would be easy for an "originality"-fetishizing American to underrate Bidou's accomplishment by asserting first of all that copying is itself inferior to "coming up with one's own ideas," and second, that no copy of a masterpiece could equal its original. As for the first issue, Zeami's adage that "if the actor can imitate perfectly a woman of pleasure, a handsome man, and so forth, then the Grace will be created of itself"[21] is relevant, although there is certainly nothing to stop an artist (perhaps a Rothko) from creating a Grace that imitates nothing, a yūgen without definite form. Well, but is the *Mona Lisa* mask as good as Leonardo's painting? Who am I to say? Long ago, when the great carver Deme Yasuhisa copied a certain Ko-Omote made by the master carver Tatsuemon—by the way, this type of Noh mask represents a lovely girl aged thirteen to seventeen—the Kanze family must have been pleased, for he did a fine job, and they wore it on the stage. Actors and carvers have told me that their masks both have a kind of "life" and are intended for use—indeed, the longer they are used, the more "life" they gain. Tatsuemon's Ko-Omote and the copy, which is better? Both are masterpieces. And so I ask you to keep an open mind in your own evaluation of what Bidou has done. Ask yourself: Does his *Mona Lisa* possess yūgen or not? Only you can say.

## 6.

What constitutes imitation? In the process of furnishing his sometimes sketchy, sometimes hyper-specific formulae for imitating courtiers, noblewomen, warriors, etcetera (for instance, he labels it "distasteful" if a masked female impersonator turns his face upward),[22] Zeami introduces the concept *monomane,* which is the reproduction of the *heart* of the model, as opposed to its miscellaneous corporeal specifics. Although the word's denotation is imitation, Rimer and Yamazaki translate it as "role playing."[23] *Monomane* begins with a suitable choice of subject: for instance, the great poetess Ono no Komachi, who figures in several Noh plays and will generally be played by a very particular mask, very likely a *rōjo* (old woman) or an *uba* (old woman). The simple fact that Komachi appears in it will "bring an appearance of artistic elegance to the play."[24] The next step is to imitate the model's inner being. Thus, to play an old man, an actor need not bend, shuffle, or stoop; indeed, Zeami would consider such to be vulgar overacting: "Above all else, an old person wishes to appear young. Yet he can do nothing about the fact that his limbs are heavy...knowing this principle represents true Role Playing. One should basically play the role in a youthful manner such as that which an old person would wish to assume. In this way the actor can show through his performance the envy which the old feel for the young."[25] And so, just as a feminine role should be tempered with masculinity, so an elderly role should be tinctured with youth. Since in Noh all things work together, ideally the masks themselves will reflect this subtlety.

So, back to Bidou and the *Mona Lisa*. Surely the fact of his having imitated her in the first place is a kind of *monomane*. Had he chosen a less celebrated original, his mask might well radiate a dimmer glow of allusiveness. (I must admit that of all the masks considered in this catalogue, it is the *Mona Lisa* that most draws me.)[26] Then comes the issue of how to represent her through "true Role Playing." As already noted, by being stripped down to a mask, the *Mona Lisa* has become partially degendered and desexualized. What we are left to concentrate on is what we most talk about anyway when we discuss her: her gaze and her smile. How that smile is "imitated" by means of carving and painting, Bidou (whom I have never met) may or may not be able to express in words. But one can work out this much: *monomane* impels the imitator to reflect the model's motivations. So, once again, why is Mona Lisa smiling? While she is representing herself to us, does she mean to seduce us, or distract us while she seduces someone else, or simply endure us, or is there still some other "manner" which she "would wish to assume"? By considering which such drive we ourselves might choose to highlight, were we in Bidou's shoes, we weigh diverging yet not exclusive possibilities, and thereby gain another opportunity to gaze at both Mona Lisas through the pleasure of *yūgen*.

I asked Bidou whether he concerned himself more with *yūgen* or *monomane*, and he replied: "To me, *monomane* and *yūgen* are like the front and back of the same thing.…The very challenge of making *utsushi* from western paintings and *ukiyo-e* becomes an attempt at expressing *yūgen*, and if I succeed I may eventually arrive at a kind of *yūgen* that is mine alone. That much said, I do not really have a sense of *monomane* in my creative efforts, because as a Noh mask maker, I have always worked with a basis in *utsushi*, which is more of a meditative act, similar to how Buddhists render calligraphic *utsushi* as a meditative discipline."[27]

It might be worth noting here that the Japanese have a special term for sutra copying, *shakyō*; according to some sutras themselves, reproducing them will enhance the merit of the copyist.[28] It might improve us all, if we could only study and reproduce the Mona Lisa's smile.

## 7.

"Basically," said Bidou, "what I do involves the same technical and spiritual aspects of *utsushi* as for other Noh masks; however, these new series require modeling from two dimensions into three, which means that I have to make those parts I cannot actually see."[29] Here is where even the staunchest American originalists must admit that imagination comes in. How the Mona Lisa's expression *ought* to change with angle is (now that she and Leonardo are dead) an insoluble question that Bidou has addressed as well as anyone. How it *does* change may be more impervious to words than I imagine. The twelfth-century poet and rhetorician Shunzei proposed that a worthwhile poem, redolent of *yūgen*, gives off an "atmosphere" that is "like the haze that trails over the cherry blossoms in spring, like the cry of the deer herd against the autumn moon."[30] Is this "atmosphere" "meaningless"? Did Leonardo's model have nothing particular in mind when she smiled, and when I see Bidou's mask from below, is the attitude of concealed anticipation or even anxiety that I seem to see the merest projection of mine?

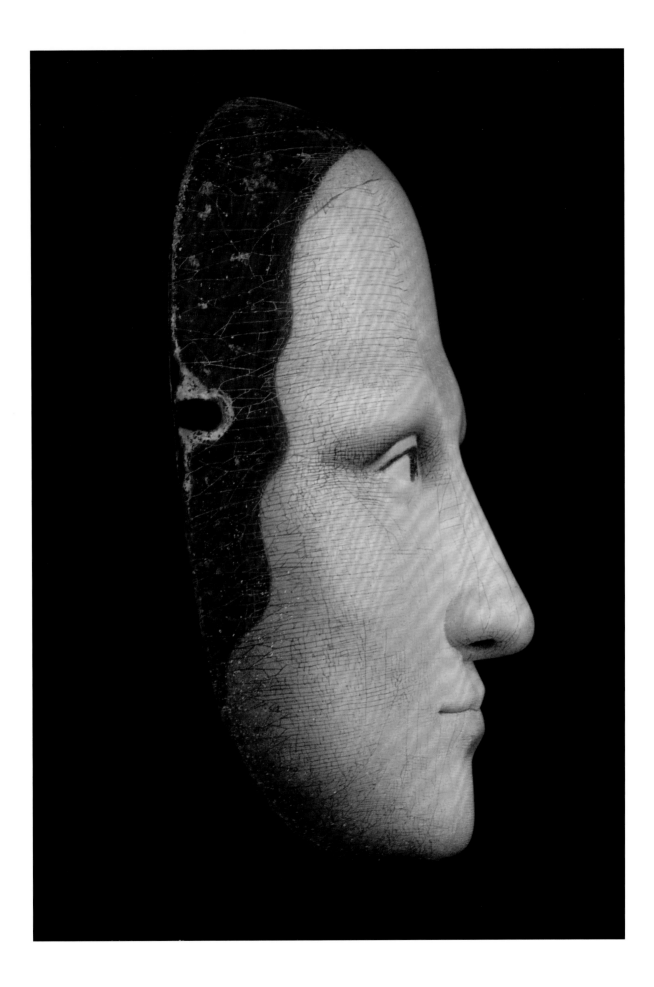

In the case of Bidou's *utsushi* of Vermeer's *Girl with a Pearl Earring,* the alteration in expression strikes me as more extreme. In its own right, Vermeer's painting may well go beyond the muted ineffability pertaining to *yūgen,* for her sidelong look is almost pathetic; and isolated by Bidou into a mask-object, the girl's expression grows still more disturbing. Is she in actual distress? I move my head from side to side, and light flickers in her pupil-holes. From below, her decapitated head practically lolls out its tongue, becoming gross and charnel-like. I am reminded of a scene in David Lindsay's spiritual parable *A Voyage to Arcturus* in which a supernatural being has been strangled: "The guests were unutterably shocked to observe that its expression had changed from the mysterious but fascinating smile to a vulgar, sordid, bestial grin, which cast a cold shadow of moral nastiness into every heart."[31] Is this "right"? Is it beautiful? Is it high art? Zeami refers to certain Noh characters whose excellence gives them the status of "jewels within jewels"—and he then lists three instances of noblewomen possessed by evil spirits: "Such a seed that is full of grace yet is capable as well of providing a proper theatrical effect on the stage represents the source of an atmosphere that is rarely met with."[32]

## 8.

I have surely written enough. The *yūgen* of these masks, like their originals, is deep, and could reward the application of several other conceptual systems. An aesthetic appreciation whose fullness comes too easily gives way to disillusionment. There is no fear of that happening in this case.

*I would like to thank Prof. Kendall Brown for all his kindness and helpfulness to me.*

# NOTES

1. Kodama Shōko, *Eigo de hanasu "Nihon no dentō geinō"* (The Complete Guide to Traditional Japanese Performing Arts) (Tokyo: Kodansha/Bilingual Books, 2000), 151.

2. George Eliot, *Middlemarch,* ed. W. J. Harvey (Baltimore, Md.: Penguin Books, 1965; reprint, London: Penguin Books, 1985), 395. Citation is to the 1985 edition.

3. Definitions after Kunio Komparu, *The Noh Theater: Principles and Perspectives,* trans. Jane Corddry (text) and Stephen Comee (plays), rev. ed. of *Nō e no izanai* (Invitation to the Noh, 1980) (New York: Weatherhill/ Tankosha, 1983), 13–14.

4. Robert H. Brower and Earl Miner, *Japanese Court Poetry* (Stanford, Calif.: Stanford University Press, 1961), 265.

5. *Sources of Japanese Tradition,* vol. 1, *From Earliest Times to 1600,* 2nd ed., comp. William Theodore de Bary, Donald Keene, George Tanabe, and Paul Varley (New York: Columbia University Press, 2001), 366.

6. Foreword to Zeami [Motokiyo], *Kadensho [Fushi Kaden],* trans. Chūichi Sakurai, Shuseki Hayashi [Lindley Williams Hubbell], Rokurō Satoi, and Bin Miyai (Ōei 25 [1442]; Kyoto: Sumiya-Shinobe Publishing Institute, 1968), 10.

7. Foreword to Zeami, *Kadensho,* 8.

8. Foreword to Zeami, *Kadensho,* 9.

9. *On the Art of the Nō Drama: The Major Treatises of Zeami,* trans. J. Thomas Rimer and Yamazaki Masakazu, Princeton Library of Asian Translations (Princeton, N.J.: Princeton University Press, 1984).

10. "To my sorrow," Bidou writes, "the Noh community frowned on such ambitions, considering them outside the mask carver's calling" (correspondence with Bidou, May 2013).

11. This is certainly the case with the mask's function. The great Noh actor Kanze Hisao once said: "It is highly detrimental to a mask to be treated like a piece of antique art, to be shut up in a box or shown only in a glass case. It is only on the stage that it continues to maintain its vitality." See William T. Vollmann, *Kissing the Mask: Beauty, Understatement, and Femininity in Japanese Noh Theater* (New York: Ecco, 2010), 287.

12. André Malraux, *The Voices of Silence,* trans. Stuart Gilbert, Bollinger series 24A (Princeton, N.J.: Princeton University Press, 1978; reprint, Princeton, N.J.: Princeton University Press, 1990; orig. pub. 1949–50), 464. Citation is to the 1990 edition.

13. Foreword to Zeami, *Kadensho,* 4.

14. Zeami, *Kadensho,* 74.

15. Personal communication with Kendall Brown, June 2013.

16. *Wa-Ei taishō Nihon bijutsu yōgo jiten, A Dictionary of Japanese Art Terms: Bilingual (Japanese and English)* (Tokyo: Tokyo bijutsu, 1990), 817 (entry for *men'uchi*).

17. [The courtier Yukinaga?], *The Tale of the Heike (Heike monogatari),* trans. Hiroshi Kitagawa and Bruce T. Tsuchida, 2 vols. (Tokyo: University of Tokyo Press, 1975; orig. Japanese text c. 1330), 86.

18. That is, for their audiences.

19. Zeami, *Kadensho,* 55.

20. Quoted in Vollmann, *Kissing the Mask,* 201.

21. Zeami, *Kadensho,* 47.

22. Zeami, *Kadensho,* 27.

23. Glossary to Zeami, *Kadensho,* 242.

24. Zeami, *Kadensho,* 149.

25. Zeami, *Kadensho,* 56.

26. The Klimt and the Munch masks are both very different from either the Leonardo or the Vermeer, for the originals are "simpler," less layered, and volumetric, and so when they are converted to three-dimensional masks, the result at first seems less impressive, like some colorful map or chart that turns out to be "thin" in information.

27. Correspondence with Bidou.

28. *Dictionary of Japanese Art Terms,* 286 (entry for *sha-kyo*).

29. Correspondence with Bidou.

30. Quoted in Brower and Miner, *Japanese Court Poetry,* 266.

31. David Lindsay, *A Voyage to Arcturus* (London: Methuen & Co., 1920; reprint, London: Victor Gollancz Ltd, 1963), 24. Citation is to the 1963 edition.

32. "Sando," *On the Art of the Nō Drama,* trans. Rimer and Yamazaki, 153.

Continuing the custom of *utsushi* (reproduction/re-creation) in Noh mask carving, and other "traditional" Japanese arts, Bidou Yamaguchi also recreates these contemporary works. For instance, *Maria Teresa* (cat. 15) is a recent reproduction of a mask first made in 2006. In contrast to the conventional western propensities for originality and uniqueness in art production, and resulting stigma attached to the copy, there is a long East Asian practice of creative copying—seeking to reproduce a model but, by necessity, changing it incrementally.

# CATALOGUE ENTRIES

Gail Schlicht

Anne Geismann Alene

Mary Grace Sanchez

David De Boer

Sheida Koufigar

B. Karenina Karyadi

Kristy Odett

Ariana Rizo

Lauren Nochella

Kendall H. Brown

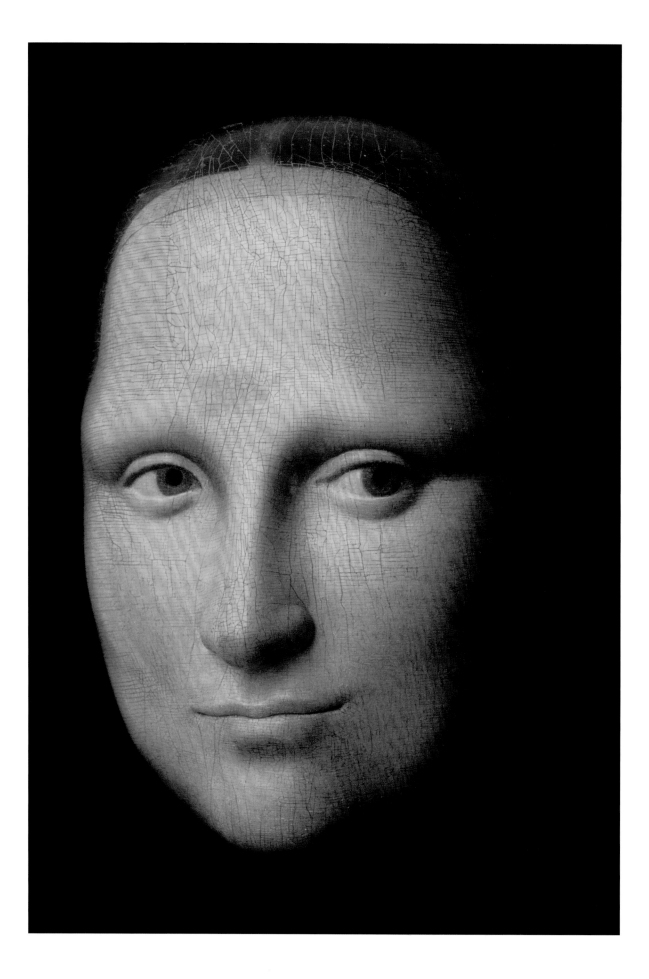

# MONA LISA

CAT. 11

BIDOU YAMAGUCHI

*Mona Lisa*, 2003

Japanese cypress, seashell,
natural pigment, lacquer

8.35 x 5.75 x 3.15 in.

Collection of Kelly Sutherlin McLeod and
Steve McLeod

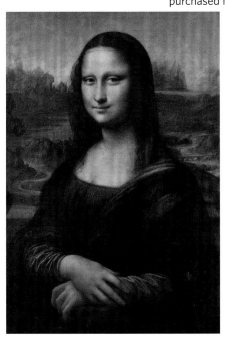

LEONARDO DA VINCI
(1452-1519)

*Mona Lisa*, c. 1503–1506

Oil on wood

30 x 21 in.

Louvre, Paris, France

The identity of the woman with the beguiling smile in this, the world's most famous painting, has been debated for centuries. The hit song "Mona Lisa" (1950) refers obliquely to this controversy in its opening phrase: "Mona Lisa, Mona Lisa, men have named you...".[1] Though scholars have posited various Italian noblewomen as the sitter,[2] orthodox opinion holds that she is Lisa del Giacondo, née Gherardini (1479-1542), the wife of a Florentine merchant. The title *Mona Lisa* means "Madam Lisa," while the painting's Italian name, *La Gioconda* (The Jovial One), puns the patron's family name. Leonardo da Vinci began the portrait in 1503, and he took it with him when he worked for the French monarch Francis I (1494-1547) at his Loire Valley château. After it was purchased from Leonardo's pupil Salaì (1480-1524), the painting entered the possession of French kings; after the revolution it was transferred to the Louvre.[3] The work's iconic status has resulted in a turbulent history, including its theft in 1911 by an Italian patriot, various physical attacks, and countless parodies.

Leonardo's subject, no matter who she is, lacks the identifying attributes typical of Renaissance portraits: jewelry, accessories, attire, hairstyle, or a coat of arms. The key to the image's iconicity—and the source of its great fame—is the sitter's enigmatic smile. Most prosaically, it connects to the books on comportment that were written for fashionable ladies of the day. These books ranked the smile as superior to the laugh, especially the quirked smile—with the right side up and the left slightly open, as if mysterious.[4] More poetically, for generations of observers, and perhaps for Leonardo himself, this smile has transformed the Mona Lisa into a muse. Such an ethereal identity would be fitting for Leonardo, who "referred to art as an invention 'which brings philosophy and subtle speculation to the consideration of the nature of all forms.'"[5]

A siren of the ages, *Mona Lisa* has inspired countless artists. While most of them maintain the two-dimensional form of the original, Bidou Yamaguchi recasts the subject's elusive beauty in an unprecedented way. Lacking the painting's temporal and ancillary elements, the mask suggests Mona Lisa's essential pathos. It reveals the woe hidden beneath her smile. She has emerged from the canvas, her movement temporarily arrested by the viewer's gaze. Amongst all of Bidou's work, one most easily imagines her in motion under the flickering torchlight of the Noh stage. In its deceptive simplicity, the mask portrays acceptance and resolve in a smile "filled with mystery, like still waters, perfectly clear, but so deep that no matter how much the gaze plunged within it, no matter how it probed, it could not see the bottom."[6] Bidou's technical acumen creates the rich patina that captures Mona Lisa's age, but her smile, timeless, is as alluring as when Leonardo's brush last kissed her.

Gail Schlicht

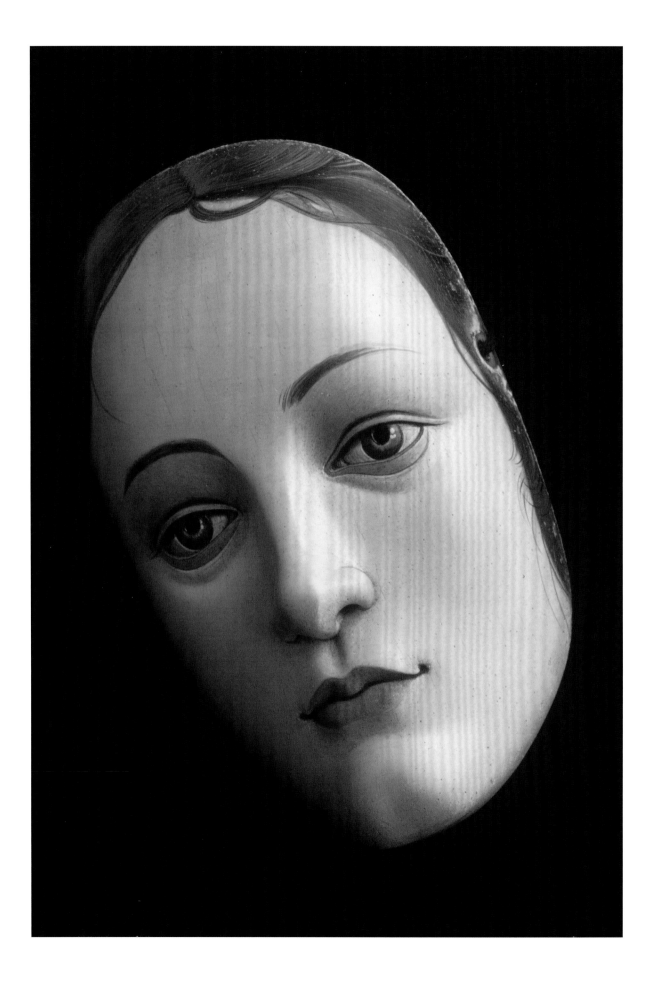

# VENUS

Cat. 12

Bidou Yamaguchi

*Venus*, 2004

Japanese cypress, seashell,
natural pigment, lacquer

8.5 x 5.24 x 3.03 in.

Courtesy of the artist

Venus was a minor Roman goddess of spring until she became identified with Aphrodite, the Greek goddess of love and beauty. The Greek sculptor Praxiteles's fourth-century BCE statue Aphrodite of Cnidus gave rise to multiple Roman copies in a genre termed *Venus pudica* ("modest Venus") because of the demure pose.[1] This "ideal" representation of the nude female form—embodying love, beauty, charm, and propriety—was adapted by Sandro Botticelli in his *Birth of Venus*.[2]

The painting was created within the sphere of the Medici family, leaders in Florentine finance, politics, and art. One theory of its origin is that when humanist scholars explained that the Roman philosopher Pliny the Elder (d. 79 CE) had lost his masterpiece painting *Venus Rising from the Sea* by the Greek artist Apelles (fourth century BCE), Lorenzo di Pierfrancesco de' Medici (1463-1503) commissioned Botticelli to recreate it.[3] Botticelli's iconography was inspired by a poem by Angelo Poliziano (1454-1494), which in turn was based on reliefs cast for the doors of the Temple of Venus.[4] The

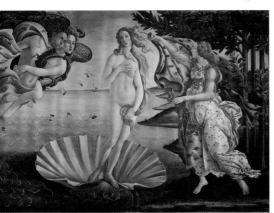

Sandro Botticelli
(1444-1510)

*The Birth of Venus*, 1486

Tempera on canvas

67.9 × 109.6 in.

Uffizzi, Florence, Italy

painting is usually read in terms of Neoplatonic philosophy, which interprets physical beauty as a springboard for spiritual beauty and intellectual love. Striving to connect with Christianity, Neoplatonism held that God was the creator of beauty, that man was made from God's love, and thus that human beauty was a vehicle for experiencing the divine. Specifically, the Greek poet Hesiod (eighth to seventh century BCE), in his *Theogony*, tells that when the Titan Cronus castrated his father Uranus and threw his testicles into the sea, Aphrodite was born out of the agitated foam, symbolizing the divine origin of beauty.[5]

In the painting, Venus's facial proportions and hair resemble those of Botticelli's model and muse, Simonetta Cattaneo Vespucci (1453-1476). The beautiful Simonetta—an object of desire for the brothers Lorenzo and Guiliano de' Medici—died at age twenty-two, a full nine years after the painting was made. Florentines are said to have immediately noted Venus's resemblance to Simonetta, and this speculation about Botticelli's love for her was "affirmed" when the painter later requested to be buried near Simonetta.[6]

This story of unrequited love, together with Neoplatonic ideas about the transformative power of beauty, make Venus a fitting subject for translation into a Noh mask. Freed from sensuous hair and body, Bidou Yamaguchi's *Venus* focuses on the young beauty's wistful eyes, with red-tinged lids and swollen skin in the wake of tears.[7] For students of Noh, the image of a beautiful woman emerging from the sea might conjure the play *Ama* (The Female Diver), a tale of Buddhist salvation, or the famous *Matsukaze* (The Pining Wind), with its theme of unrequited love set along the seashore. One can imagine a new play about Simonetta as a muse who left behind her image as Venus, and the artist Botticelli, whose unfulfilled love led to the creation of great beauty and, perhaps, to his spiritual release.

Anne Geismann Alene

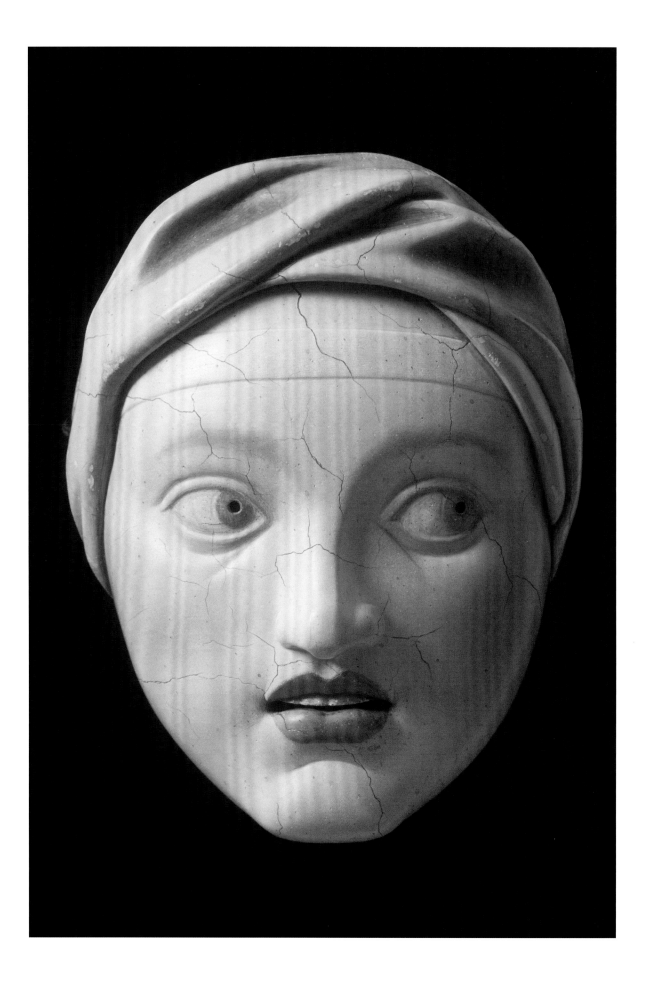

# Delphic Sibyl

Cat. 13

Bidou Yamaguchi

*Delphic Sibyl*, 2007

Japanese cypress, seashell,
natural pigment, lacquer

8.46 x 6.69 x 3.66 in.

Courtesy of the artist

Enthralled by the Sistine Chapel's grand themes, humanistic style, and trompe l'oeil effects, most of its visitors experience it with spiritual awe. From 1508 to 1512, Michelangelo painted its ceiling as a commission for Pope Julius II (1443–1513), depicting nine scenes from the book of Genesis—including the iconic *Creation of Adam,* an image only slightly less famous than Leonardo's *Mona Lisa.* Around the perimeter, on the pendentives, Michelangelo alternated portrayals of the seven Prophets of Israel with those of five Greco-Roman Sibyls to show how the Old Testament prefigured the New Testament, and how oracles of the classical world prophesized Christ's birth.[1] Earlier Italian painters had established the practice of juxtaposing Sibyls and Christian figures to reflect the embrace of Greco-Roman culture by Renaissance humanists.[2]

Michelangelo depicts the mythic Delphic Sibyl with startled eyes, caught in the moment of an oncoming vision. Delphica's prophecies, recorded in hexameter in

the *Libri Sibyllini* (Sibylline Books),[3] predicted that "a prophet [would] be born without his mother's coition, from a virgin."[4] Christian theologians interpreted this prophecy to enforce the biblical authority of Christ's virgin birth. This legendary prediction and reinterpretation account for the Delphic Sibyl's presence among the 343 figures on the Sistine Chapel ceiling.

Bidou Yamaguchi's *Delphic Sibyl* continues this transference of identity from Grecian Sibyl to Christian prophetess to implicit Noh character. In severing the face from the powerful and masculine body typical of Michelangelo's figures, Bidou stresses the Sibyl's youthful, feminine visage. Further, by emphasizing the curved, slightly parted lips that issue a prophecy, and the illuminated eyes that gaze into a world beyond, Bidou transforms the Delphic Sibyl into the kind of possessed female character found in some Noh plays. Her tense, rounded face and curved, open mouth suggest a basic connection with the Zō-Onna mask. Both embody the sublime and spiritual aura of mythological women given an aristocratic mien.[5] These women

Michelangelo Buonarroti
(1475-1564)

*The Delphic Sibyl* (detail of the
Sistine ceiling), 1508–1512

Sistine Chapel, Vatican Palace,
Vatican State

speak of other times: the Sibyl reveals the future, whereas the Noh characters clarify the ambiguity of the past.

Bidou's sculpture facilitates multiple physical perspectives and opens Michelangelo's Delphica to various interpretations. Most basically, Bidou imbues the Greek Sibyl with the mystery and opacity redolent of *yūgen.* Yet, in contrast to the frontality of Noh masks that engage the spectator, the Sibyl refuses to reciprocate the viewer's gaze and seems to constantly defer engagement, lost in her vision. By isolating the Delphic Sibyl from her religious environment, Bidou compounds the content of the Sibyl's message, letting the audience imagine the new prophecies that she might reveal. It is said that after her death, like a Noh character, Delphica became a wandering spirit, imparting the dark mysteries of the future.

Mary Grace Sanchez

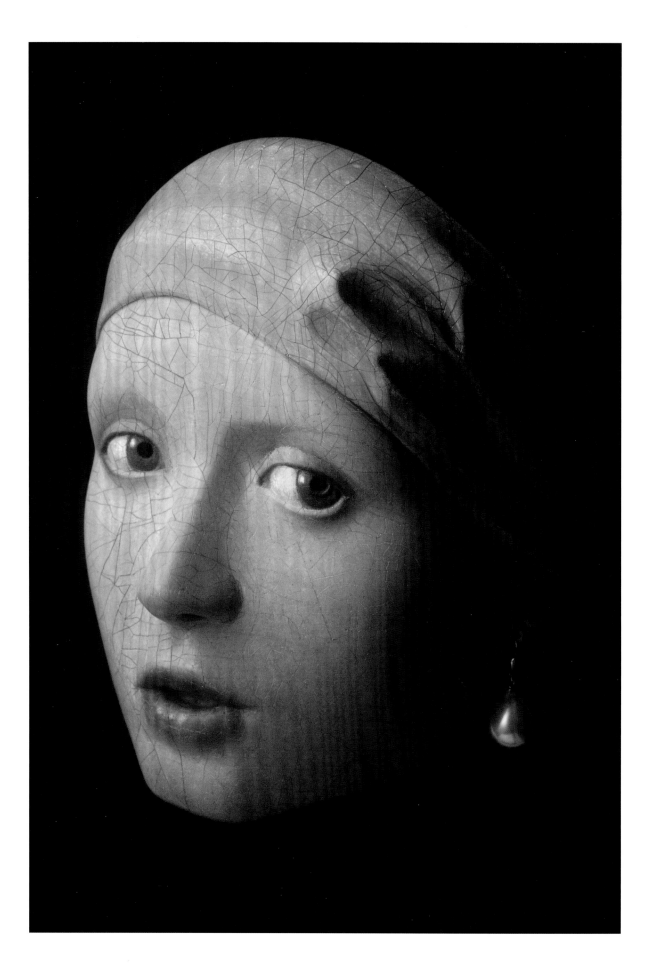

# GIRL WITH A PEARL EARRING

CAT. 14

BIDOU YAMAGUCHI

*Girl with a Pearl Earring*, 2005

Japanese cypress, seashell,
natural pigment, lacquer

7.87 x 6.65 x 4.52 in.

Collection of Kelly Sutherlin McLeod and
Steve McLeod

"It is me at whom she gazes...with an intensity that demands something just as real and human in return," writes Edward Snow of *Girl with a Pearl Earring,* in his study of Johannes Vermeer.[1] The intimacy of the moment reveals how Vermeer, captivated by his own artifice, must betray his inspiration and submit to the demands of the work being created. The artist Paul Klee (1879–1940) described this threshold as the instant in which a painting acquires a face. "Now it looks at me," he declared.[2] In this painting of pervading timelessness, Vermeer simultaneously stimulates and arrests our ability to peer back at his subject while depicting a gaze of pure vulnerability.[3]

Delivered from the surrounding darkness, Vermeer's *Girl* implicates the viewer's presence with the apprehension of her mouth and the amazement in her eyes. Holding us accountable, her unresolved desire deprives the spectator of the usual

JAN VERMEER (VAN DELFT)
(1632-1675)

*Head of a Girl (Girl with the Pearl Earring)*, c. 1665

Oil on canvas

17.52 x 15.35 in.

Mauritshuis, The Hague,
The Netherlands

distance enjoyed when looking at painted figures. This realization is the subject of Bidou Yamaguchi's *Girl with a Pearl Earring,* with its complex construction of her expression. Materializing her face in a mask cloaks her identity by removing it from its pictorial frame and historical context, yet it also expands on that mysterious identity by creating a presence beyond that of the painting. In fact, it is the mask that is meant to conceal, while the presence of its iconic "look" makes us its object.

*Girl with a Pearl Earring,* the so-called "Dutch *Mona Lisa*", did not gain its status as Vermeer's masterpiece until it was given to the Mauritshuis in the early 1900s. Although lacking the pictorial and moral complexities of most seventeenth-century Dutch portraits, the figure's depiction is consistent with the Delft tradition of *tronie,* a painting that captures a particular expression.[4] The work's mystique has flourished as the painting has become the source for various fictions. In her best-selling novel *Girl with a Pearl Earring,* and the subsequent film, Tracy Chevalier creates an intimate tension between the painter and his young model based on the girl's "ambiguous look" and "mystery" in the painting.[5] From here, it is only a short step to imagine other scenarios for the *Girl,* including Noh plays with stories of longing, suffering, and release.

Finely crafted, Bidou's mask parallels the meticulous workmanship of Vermeer's painting. It evokes art critic Jan Veth's description of *Girl with a Pearl Earring* as a work that "looks as if it were blended from the dust of crushed pearls."[6] More important, by moving beyond a fleeting moment to extend its gaze at the outer world, Bidou's *Girl* opens up potential contexts that project her beyond the past. Whereas Chevalier posits the psychological intrigue between the model and the artist based on ideas of creation, violation, and individual identity, Bidou releases the exquisite face from such speculation. Instead, the unguarded emotion confronts us and becomes real.

David De Boer

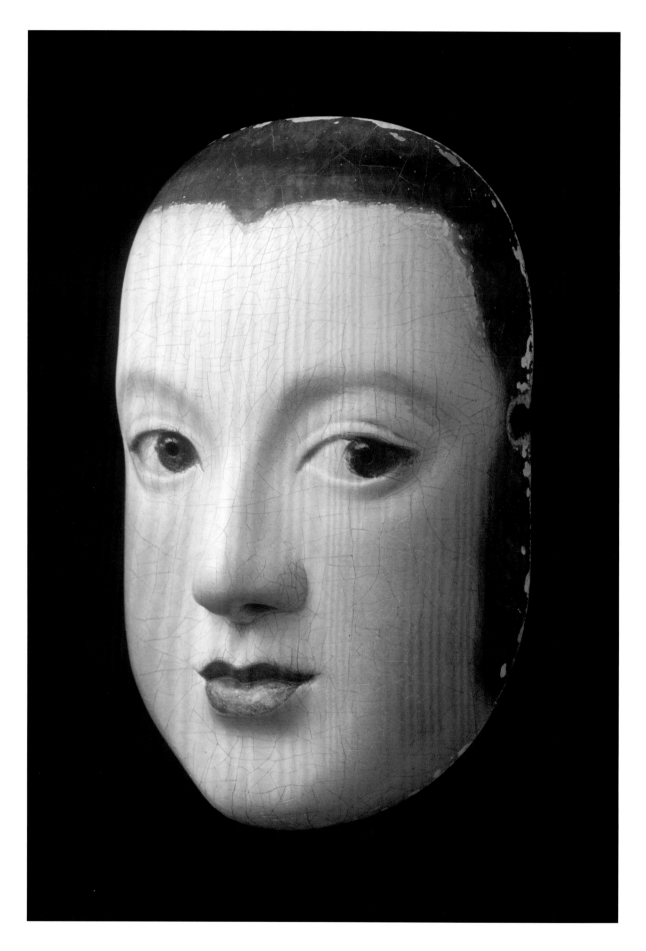

# MARIA TERESA

Cat. 15

Bidou Yamaguchi

*Maria Teresa*, 2013
(after 2006)

Japanese cypress, seashell,
natural pigment, lacquer

7.48 x 4.88 x 3.07 in.

Courtesy of the artist

"Among all the monarchs of that faithless age, the nearest to a man was a woman." So wrote G. K. Chesterton of the Hapsburg queen Maria Teresa.¹ The daughter of Philip IV of Spain (1605-1665) and Elisabeth of France (1602-1644), Maria Teresa (1638-1683) was among the most influential women of her time. With the death of her brother, Prince Baltasar Carlos (1629-1646), she became heir presumptive to the Spanish throne. Spain's need for peace with France led to her marriage to her first cousin Louis XIV (1638-1715), whereupon Maria Teresa became queen of France in 1660.

Maria Teresa's political significance made her a center of artistic attention. Portrait specialists painted her in the various stages of her life, although she is best known from the work of Spanish court artist Diego Velázquez. However, it is her half-sister, Margaret Teresa (1651-1673), who is depicted in his iconic *Las Meninas* (The Maids of Honor). Velázquez's *Maria Teresa, Infanta of Spain* showcases the artist's signature style for royal portraits in the exaggerated makeup and elaborate wig.² Arguably, even as the painting celebrates Maria Teresa's political status through the pomp of her coiffure and costume, Velázquez exaggerates the fourteen-year-old's youth to set up a haunting contrast between the political utility and personal vulnerability of a young woman who, just six when her own mother died, was then raised by her distant stepmother, Mariana of Austria (1634-1696).

Diego Rodriguez Velázquez
(1599-1660)

*Maria Teresa, Infanta of Spain*,
1651–1654

Oil on canvas

13.5 x 15.75 in.

The Jules Bache Collection, 1949
(49.7.43)
The Metropolitan Museum of Art,
New York, NY, U.S.A.

In his three-dimensional portrayal, Bidou Yamaguchi underscores Maria Teresa's feminine purity. The demands of the Noh mask format abstract the youthful face from its accoutrements of power. She is shorn of her majestically coiffed and butterfly-bedecked hair, and, in contrast to several of Velázquez's other portraits—made when Maria Teresa's hand in marriage was being widely negotiated—she is removed from elaborate gowns.³ Although in Velázquez's work, Maria Teresa appears younger than her age at the time would suggest, Bidou's depiction seems even more youthful, as he smoothes her skin and slightly rounds her face. Bidou's *Maria Teresa* seems to take on the characteristics of the youthful Ko-Omote mask—the "idealized portrayal of a young woman who no longer is a child."⁴

When the image is changed from the temporally specific painting to the time-shifting Noh mask, the viewer more easily projects onto this "expressionless" portrait the full arc of Maria Teresa's biography. The apparent naiveté of the youthful princess stands in stark contrast to the sorrow of the French queen. After a happy first year with Louis, she reportedly suffered through the Sun King's many affairs, gaining weight, and withdrawing from court life. Tragically, of Maria Teresa's six children, three died as infants and two as toddlers. This knowledge casts a shadow of pathos over Bidou's graceful depiction. In sum, Bidou's mask gives the viewer "a dedicated balance between the mimetic portrayal of a character, and a quality of transcendent grace and beauty *(yūgen)*."⁵

Sheida Koufigar

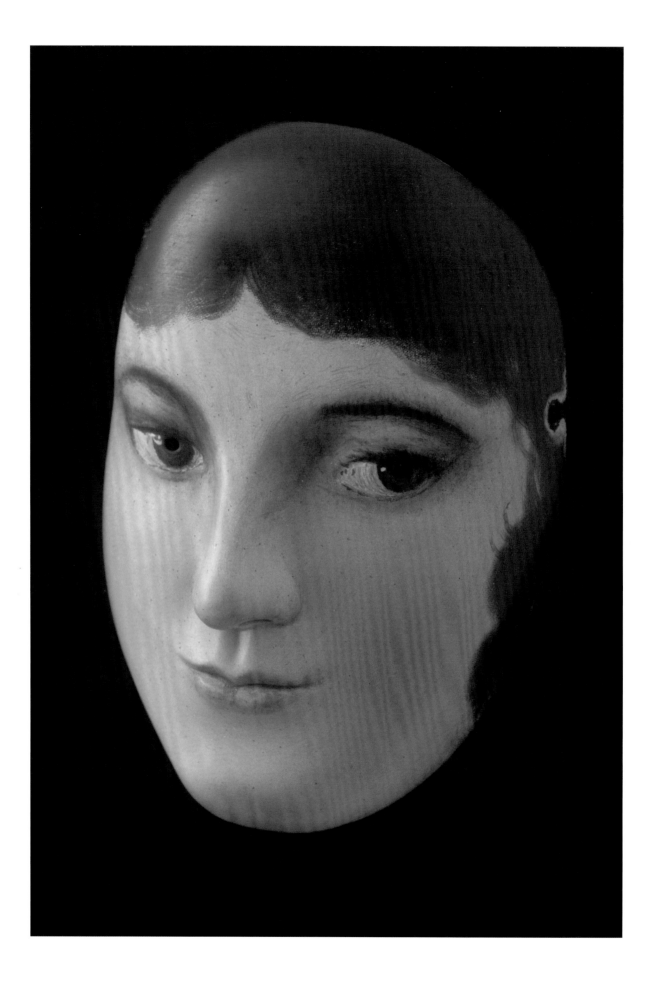

# Maja

CAT. 16

BIDOU YAMAGUCHI

*Maja*, 2006

Japanese cypress, seashell,
natural pigment, lacquer

8.31 x 5.67 x 3.62 in.

Courtesy of the artist

*The Nude Maja*, the seductive and mysterious masterpiece of Francisco Goya, was first recorded as being seen in 1800 in the "secret study" of Spanish prime minister Manuel Godoy (1767-1851). The origin of the commission and that of its twin, *The Clothed Maja* (c. 1807-8), remain unknown.[1] Speculation also surrounds the subject's true identity, with strong candidates being the powerful 13th Duchess of Alba, María Cayetana de Silva (1762-1802), and Godoy's longtime mistress, Pepita Tudó (1779-1869).[2] History does reveal that the Spanish Inquisitors condemned the paintings, confiscating them and censuring Goya. Even though rooms dedicated to paintings of nude figures were not new in Godoy's time, his collection featured "works that removed the nude from any narrative context," and thus, for the first time, posited the secular nude as an icon.[3]

Although created in a conservative place and time, *The Nude Maja* is a symbol of female sexuality. The voluptuous figure reclines majestically in a dark sea of velvet, silk, and lace. Her direct, unapologetic gaze arrests the observer, "thus transforming the encounter between them into an erotic occasion."[4] The paired paintings were reportedly installed on a mechanized system, allowing *The Nude Maja* to hide behind its more modest sister when convention dictated, waiting to be revealed again.[5] A similar tension between concealment and revelation informs the basic function of masks and the central core of Noh's "woman plays." These plays, rooted in the female literary traditions of the Heian era (794-1185)[6] and central tenets of Buddhism, present a metaphorical and physical masquerade that covers the distinguishing features of actual women behind a fictional façade. Yet, the plays simultaneously disclose each female character's essence by focusing on aspects of her womanhood—

FRANCISCO DE GOYA Y
LUCIENTES (1746-1828)

*The Nude Maja*, 1797–1800

Oil on canvas

38 × 75 in.

Museo del Prado Madrid

something Goya does literally in *The Nude Maja* by placing "her pubis [at] the center of the composition."[7]

Bidou Yamaguchi's *Maja* explores the tension of this duality through its transfiguration of the painting's form. Because the face is the single constant element between the painting and Bidou's sculpture—and between the twinned paintings—it replaces the subject's body (clothed or nude) as the identifying feature. She is reduced, and elevated, to her facial features—lustrous dark hair, captivating eyes, strong brows and nose, and firm yet sensuous mouth—and the indeterminate character they might express. Divested of clothes and body, Bidou's *Maja* floats free, able to project new narratives that shape her identity.

As such, the cycle of reality and irreality in Noh comes full circle in Bidou's mask.[8] While most literary and visual creations draw from real-life accounts, the mask inspires fictionalization in new plays that might be created for it. Like the female characters in "woman Noh," whose release from spiritual transience is only possible through their retelling of the past, the subject transcends the superficiality of two-dimensional flatness to acquire a new life in three dimensions.

B. Karenina Karyadi

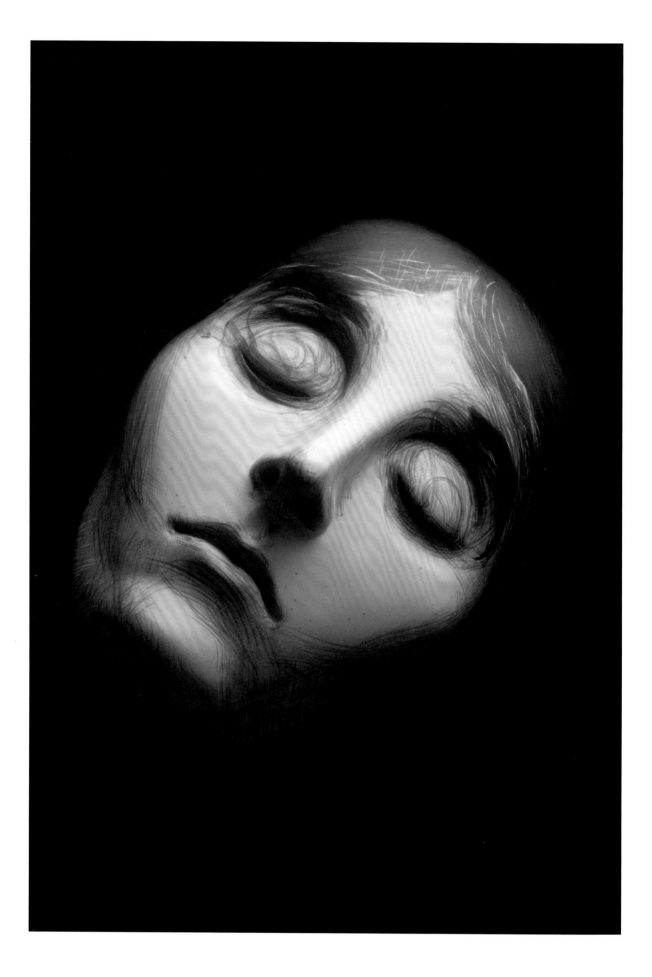

# Madonna

CAT. 17

BIDOU YAMAGUCHI

*Madonna*, 2006

Japanese cypress, seashell,
natural pigment, lacquer

8.15 x 5.94 x 3.78 in.

Collection of Kelly Sutherlin McLeod and
Steve McLeod

In works like *Madonna,* Edvard Munch's expressionistic Symbolism reflects his disparate beliefs and experiences. A member of the bourgeoning avant-garde movement in Paris and Germany, Munch became fascinated by mysticism and psychology. Driven to create universal truths through lived experience, Munch proclaimed, "My art is a self-confession. Through it, I seek to clarify my relationship with the world...to help others to clarify their own search for truth."[1] This sentiment is encapsulated in the series *Frieze of Life,* depicting life, love, and death. In this series, *Madonna,* also called *Loving Woman,* is Munch's icon of love. The model is likely the writer Dagny Juel-Przybyszewska (1867–1901), an intimate of Munch, or Millie Ihlen Thaulow (1861–1924), Munch's cousin's wife, with whom he had a passionate affair.[2]

EDVARD MUNCH (1863-1944)

*Madonna (Conception),*
1895–1902

Lithograph

23.8 x 17.5 in.

Munch Museum, Oslo, Norway

Munch's *Madonna* lithograph re-creates on its border the sperm and fetus-like embryo painted on the frame of the original oil painting. It also shifts the Madonna from yellow to white. Interpreted as the source of life and a harbinger of death, she defines the role of women in terms of duality. For Munch, the Madonna is "the whole mystery of development condensed into one scene. The many-faceted nature of woman is a mystery to man. Woman...is at the same time a saint, [and] a whore."[3] This juxtaposition is evident in the sacred title and halo, and in the depiction of a woman at the moment of orgasm. Her position of repose exemplifies the French euphemism for orgasm, *la petite mort* (the little death). In Munch's conception, women link death and life.[4]

Munch's eroticized bust-length *Madonna* implies a male viewer who activates the scene by embodying her lover, initiating and consummating the moment.[5] By contrast, Bidou Yamaguchi's *Madonna* reincarnates the woman. By severing her head from the eroticized contexts of frame, background, and body, Bidou disengages her from a male partner. In making her solid, Bidou literally decorporealizes the Madonna and accentuates her deathlike repose in a vision of sorrow and beauty. Viewers may engage with *Madonna* as lovers, suppliants, or mourners; they may even assume the mask-wearing role of the Noh actor and become an incarnation of the Madonna.

A face of serenity surrounded by chaos, Bidou's *Madonna* transcends Munch's presentation of woman as saint and whore. It also complicates Japanese markers of feminine identity, because in female Noh masks, tangled hair indicates emotional distress, and heavily lidded eyes suggest suffering in purgatory.[6] Bidou uses these signifiers in an image of tranquility. Untethered from Christianity and Munch's psychosexuality, Bidou's *Madonna* assumes the neutral expression and fluid identity of many female Noh masks. A woman for all seasons, she has the tangled hair of the spirit woman Ryo no Onna, the soft lower lip of the youthful beauty Zō-Onna, the sunken cheeks of Yase-Onna, the downcast eyes of Yoroboshi, and the world-weariness of the sorrowful mother Shakumi.

Kristy Odett

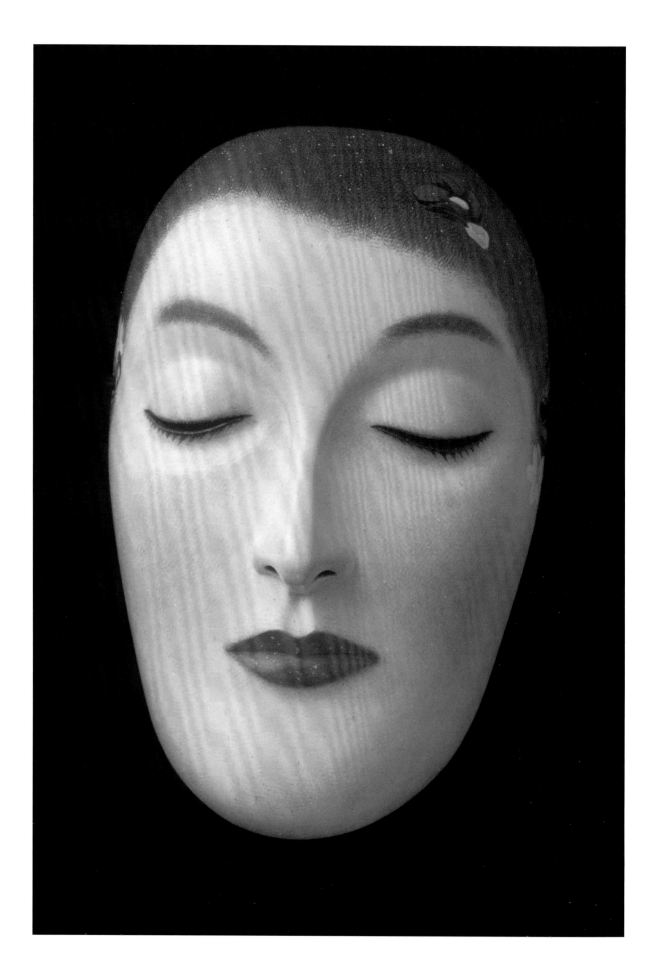

# Kiss

CAT. 18

BIDOU YAMAGUCHI

*Kiss*, 2007

Japanese cypress, seashell,
natural pigment, lacquer

8.27 x 5.35 x 3.11 in.

Collection of Kelly Sutherlin McLeod and
Steve McLeod

Turn-of-the-century Vienna was a place of explosive growth in industry, investment, and the investigation of new ideas. Situated between western and eastern Europe, Vienna saw revolutionary achievements by writers, artists, and philosophers who paved the way for modern thought. Paradoxically, Vienna's "golden age" unfolded under the conservative reign of Austrian emperor Franz Josef (1830-1916). More important, however, was the patronage of the city's new, largely Jewish, bourgeoisie, whose tastes ranged from the psychosexual analyses of Sigmund Freud (1856-1939) to Japonisme in art.[1]

In works like *The Kiss,* Gustav Klimt captures this mood of opulence and innovation. After painting in an academic style, from the 1890s Klimt largely explored a new direction as part of the Vienna Secession movement that "reacted against the prevalent naturalism of academic painting."[2] Painted around 1908, *The Kiss* isolates two naturalistically rendered figures within a cacophony of gold leaf and color, geometric and organic forms. Its flat treatment of space is adapted from Art Nouveau, which itself borrowed from Japanese woodblock prints.[3] A modern evocation of the timeless theme of love, *The Kiss* was embraced by critics and the public upon its exhibition, and it was immediately acquired by the Austrian Gallery of Vienna's Belvedere Palace.

*The Kiss* may portray Klimt and his longtime mistress, fashion designer Emilie Louise Flöge (1874-1952). While disputed by some scholars, this claim adds a layer of mystique to the already highly romantic image, in which the differently patterned gold robes of the embracing couple intertwine so completely that they merge into a single form. Even though relatively chaste compared to Klimt's other works—many of which were called "painted pornography"—the painting has become an emblem of erotic love.[4] Klimt's use of gold leaf and decorative motifs around the academically rendered figures gives the work both a hyper-modern appearance and a resemblance to Byzantine mosaics. The two lovers stand as modern icons.[5]

In transforming the painting into a mask, Bidou Yamaguchi excises the work's most iconic and modern qualities: the gold background and abstract forms. Bidou isolates the woman being kissed from the embrace of her lover—arguably removing Klimt from his own painting—and erases Klimt's symbolic and narrative elements. What remains in the sculpture is the female face, whose identity would be hard to determine without a title. It is exactly this ambiguity of identity that allows for Bidou's *Kiss* to be read as a potential Noh character. The woman's pale, youthful complexion recalls the elegant beauty of the Waka-Onna mask, used in plays about young women longing for an unattainable love or for salvation. More specifically, her downcast eyes and arched brows derive from the Semimaru mask,[6] which Bidou has also appropriated for *Angelina* (cat. 20), made in the same year. Ultimately, Bidou transforms Klimt's beauty from a sexually charged, modern Viennese woman to a passive spirit suspended in a state of longing, and waiting eternally for a kiss.

Ariana Rizo

GUSTAV KLIMT (1862-1918)

*The Kiss*, 1907–1908

Oil on canvas

70.87 x 70.87 in.

Oesterreichische Galerie im Belvedere,
Vienna, Austria

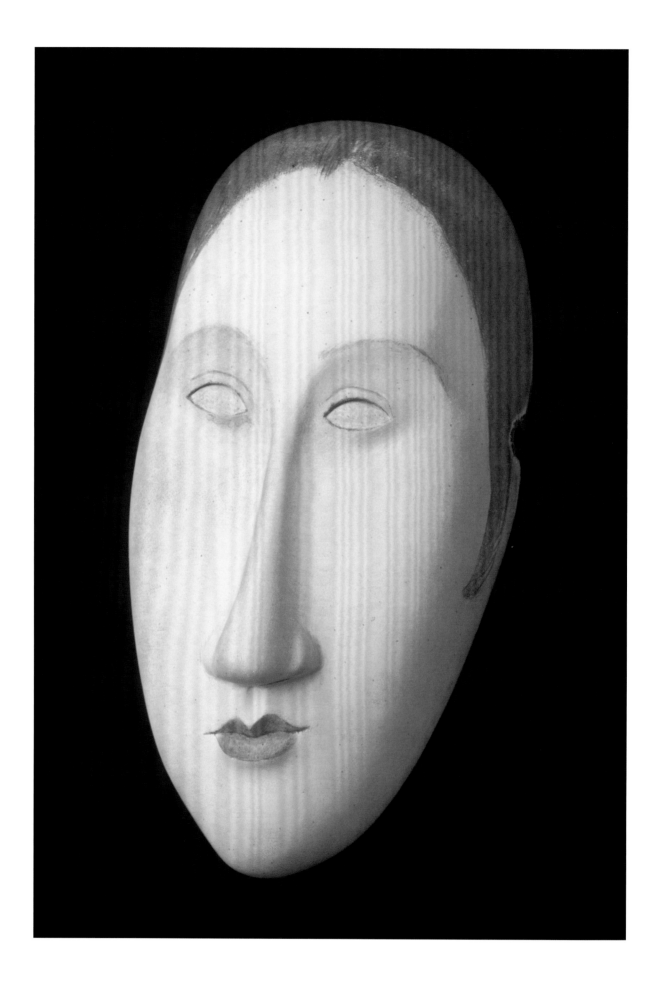

# JEANNE

CAT. 19

BIDOU YAMAGUCHI

*Jeanne*, 2006

Japanese cypress, seashell,
natural pigment, lacquer

9.21 x 4.92 x 2.87 in.

Collection of Kelly Sutherlin McLeod and
Steve McLeod

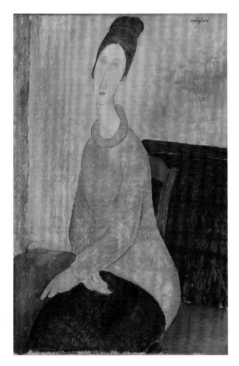

AMEDEO MODIGLIANI
(1884-1920)

*Jeanne Hébuterne with Yellow
Sweater*, 1918–1919

Oil on canvas

39.38 x 25.5 in.

By gift of Solomon R. Guggenheim
Founding Collection
The Solomon R. Guggenheim Museum,
New York, NY, U.S.A.

Residing in Paris during World War I, Amedeo Modigliani led a life marked by passion and poverty. In 1917, he found acclaim and notoriety for an exhibition of nude portraits, and he met the nineteen-year-old art student and ingénue Jeanne Hébuterne (1898–1920). Despite the impassioned objections of her parents, the Catholic Jeanne lived with the Jewish Modigliani, and in 1918 they had a daughter. Although fanatically devoted to Modigliani, Jeanne was no match for his wild genius, furious tantrums, and self-destructive temperament. When Modigliani died of tubercular meningitis on January 24, 1920, the distraught Jeanne committed suicide a day later. Her leap from a fifth-story window also killed their unborn child.[1]

In fewer than three years, Modigliani had immortalized Jeanne in over twenty paintings. *Jeanne Hébuterne with Yellow Sweater* only hints at the couple's tumultuous relationship in its intense hues of red, gold, and blue.[2] Modigliani depicts Jeanne with a subtle mix of nascent, unselfconscious sensuality and childlike trust, yet one senses that more is hidden than revealed. He exaggerates her long, swan-like neck and coppery hair, and he renders her alabaster skin with a translucence that suggests her nickname, "Noix de Coco," or coconut. Jeanne's mysterious expression and almond-shaped eyes—a mingling of green, blue, and hazel, with one iris floating slightly off-center—give her a languid melancholy and extreme delicacy that Italians call *morbidezza*.[3]

Art historians have interpreted much modern portraiture, including Modigliani's, in terms of the influence of "primitive" art, especially African masks.[4] Modigliani's faces are often termed mask-like, though their sensitivity to the sitter's personality is linked to Renaissance portraits. Modigliani claimed far larger influences, writing, "I am the plaything of powerful forces that are born and die in me," and, "Beauty makes painful demands, but these bring forth the supreme efforts of the soul."[5] These grandly romantic sentiments, together with his tragic life, have made Modigliani a symbol of the bohemian artist's heroic sacrifice for art and love—a status refined in several novels and films about his life.

Bidou Yamaguchi's choice of *Jeanne* for a Noh mask seems destined, as her story of tragic sacrifice for love is worthy of a female lead role in one of Noh's "woman plays." The end of such a play could be Jeanne and Modigliani's reunion in 1930 in Père Lachaise Cemetery, where their grave has become a place of tribute. In *Jeanne*, Bidou reproduces Modigliani's distorted angles and flickering color to capture what the French call *jolie-laide* (pretty-ugly) to indicate a beauty of innuendo and of implication. This *Jeanne* reveals Hébuterne's tenuous presence and Modigliani's tortured soul. And though different in form from Noh masks, like many of them, this face expresses the quietly elegant grace of a woman's spirit born from great sadness.

Lauren Nochella

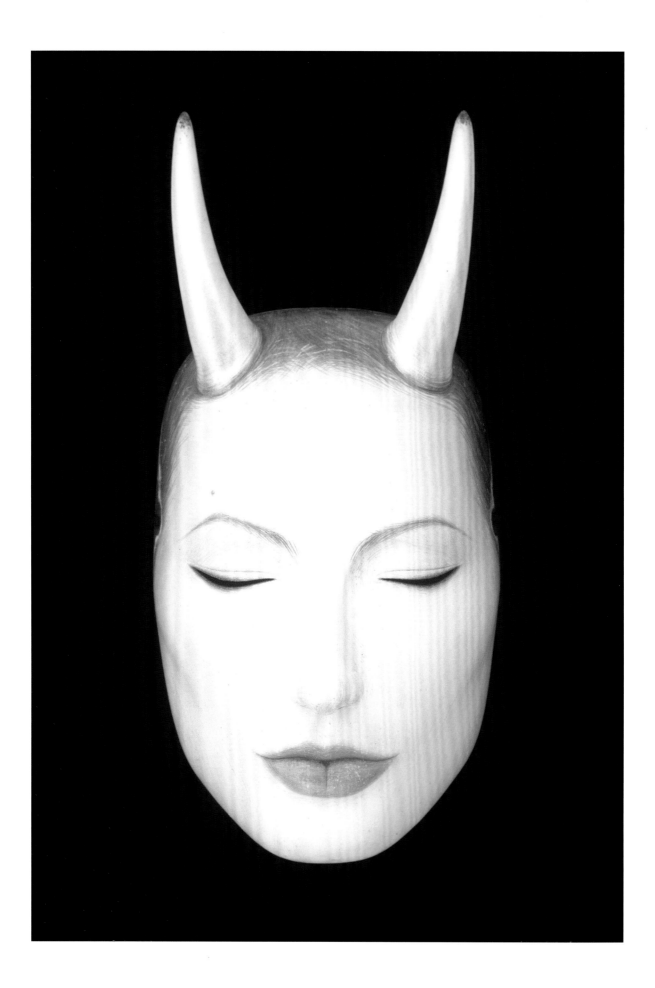

# Angelina

Cat. 20

Bidou Yamaguchi

*Angelina*, 2007

Japanese cypress, seashell,
natural pigment, lacquer

10.83 x 5.35 x 3.62 in.

Courtesy of the artist

This mask presents the iconic actress Angelina Jolie (b. 1975) as a character for a potential Noh play. Known for her acting, her personal difficulties, and her philanthropy, Jolie is one of the world's most famous and influential celebrities. After troubled teenage years of drug use, self-mutilation, and estrangement from her father, the actor Jon Voight (b. 1938), she gained fame for her Academy Award–winning role as a charismatic sociopath in *Girl, Interrupted* (1999), and for her stormy marriages to actors Jonny Lee Miller (b. 1972) and Billy Bob Thornton (b. 1955). These relationships suggested an emotional instability like that of her film characters. This interpretation was underscored by Jolie's fascination with blood and by her tattoos of Tennessee Williams's phrase, "A prayer for the wild at heart, kept in cages," and the Latin motto "*Quod me nutrit me destruit*," meaning, "What nourishes me, destroys me."

Jolie's title role in the 2001 film *Lara Croft: Tomb Raider* turned her into a global star and inspired her to adopt a Cambodian orphan. Subsequently, Jolie joined and established various humanitarian projects, and in 2001 she was appointed Goodwill Ambassador for the United Nations High Commissioner for Refugees. With her partner, actor Brad Pitt (b. 1963), from 2005, Jolie adopted two more children and had three with him.[1] In the years between the mask's creation in 2007 and this catalogue, Jolie has become better suited for transformation into the Noh realm, where characters often struggle to transcend physical and emotional bonds. In a 2013 *New York Times* essay, Jolie revealed that, owing to a genetic predisposition for the cancer that killed her mother, Marcheline Bertrand (1950–2007), she had undergone a preventative double mastectomy.[2]

Jolie's great beauty, dramatic biography, and powerful celebrity made her a compelling choice for Bidou Yamaguchi's only mask of a living person. To understand Jolie's face, Bidou looked at photos of her from various angles. The mask, however, is frontal, like Noh masks, and it rejects the three-quarter view prevalent in his works that reproduce portraits. This frontality expresses Bidou's desire to make masks that might be worn for a newly created play. It combines two Noh mask types. The elegantly aristocratic face with downcast eyes comes from *Semimaru*, a play about a young prince whose blindness led to his abandonment.[3] The horns derive from the Hannya mask, showing a woman turned demon by obsessive love, yet sorrowful in her torment.

*Angelina* is a shape shifter and a cross-cultural femme fatale. She reprises the Japanese idea of the beautiful woman who ultimately reveals her true form—an inherent evil based on inescapable carnality attributed to women in Buddhism, and expressed by horns of jealousy. However, given Jolie's personal transformation from roiled symbol of sex and death to icon of maternal generosity, it is tempting to invert this interpretation and read the mask as portraying an obsessive nature giving way to the calm of wisdom.[4]

Kendall H. Brown

# Notes

## Mona Lisa

1. The song "Mona Lisa," written by Ray Evans and Jay Livingston, won the Academy Award for Best Original Song in 1951; the recording by Nat King Cole spent eight weeks at number one on the Billboard charts the previous year.

2. Arguments for misattribution claim a transcription error in financial records that was perpetuated by Giorgio Vasari in his series of artist biographies, *Lives of the Artists*. See Jack M. Greenstein, "Leonardo, Mona Lisa, and *La Giaconda*: Reviewing the Evidence," *Artibus et Historiae* 50 (2004): 19–22.

3. Greenstein, "Leonardo," 19.

4. Roy McMullen, *Mona Lisa: The Picture and the Myth* (New York: Da Capo Press, 1977), 80. See also Donald Sassoon, *Becoming Mona Lisa: The Making of a Global Icon* (New York: Harcourt, 2001).

5. Quoted in McMullen, *Mona Lisa*, 125.

6. McMullen, *Mona Lisa*, 182.

## Venus

1. The mother of Aeneas, an ancestor of Rome's founder, Romulus, Venus was venerated at Caesar's family temple.

2. The painting, the most popular work in Florence's Uffizi Gallery, has a complex narrative that reads from left to right. Winged Zephyrus wafts the newborn Venus along his westerly wind, embracing a wind goddess and scattering roses into the sea. Venus floats on a conch shell, gazing calmly, covering her vulnerable exposure with her right arm and just the ends of her hair. She drifts toward Pomona, nymph of spring and fruit trees, waiting ashore, ready to cover the nude Venus with a brocade garment.

3. Bruno Santi, "Botticelli," *The Protagonists of Italian Art* (Florence: Scala, 2001).

4. Poliziano's poem *La Giostra* (1475–78) reads: "In the stormy Aegean...wrapped in white foam...a young woman with nonhuman countenance, is carried on a conch shell, wafted to shore by playful zephyrs...it seems that heaven rejoices in her birth." Poliziano, *The Stanze of Angelo Poliziano*, trans. David Quint (Amherst: University of Massachusetts Press, 1979), stanza 99.

5. For the birth of Aphrodite as described in Hesiod, see *The Theogony*, trans. Hugh G. Evelyn-White (Cambridge, Mass.: Harvard University Press, 1914), lines 176–206.

6. The much-debated issue of Botticelli's model and muse is the focus of Stefan Buske, *Sandro Botticelli, Weibliches Brustbildnis (Idealbildnis Simonetta Vespucci?)* (Sandro Botticelli, Portrait of a Woman, Idealized Portrait of Simonetta Vespucci?) (Frankfurt: Städel, 1988).

7. This detail can be seen in the high-quality scan of *Birth of Venus* provided on the Google Art Project website, http://www.googleartproject.com.

## Delphic Sibyl

1. Marcia B. Hall, *Michelangelo: The Frescoes of the Sistine Chapel* (New York: Harmony Books, 1986), 17. See also George L. Hersey, *High Renaissance Art in St. Peter's and the Vatican: An Interpretive Guide* (Chicago: University of Chicago Press, 1993). The other Sibyls are Cumea, Persicha, Libica, and Erithraea.

2. Hall, *Michelangelo*, 90.

3. H. W. Parke, *Sibyls and Sibylline Prophecy in Classical Antiquity* (New York: Routledge, 1988), 10. In book 3 of the *Sibylline Books*, the Delphic Sibyl identifies herself as the half-sister of Artemis, asserting her authority for divine revelation.

4. Hall, *Michelangelo*, 94.

5. David Wiles, *The Masks of Menander: Sign and Meaning in Greek and Roman Performance* (Cambridge: Cambridge University Press, 2004), 102. Wiles discusses the universality and popularity of the Zō-Onna mask in Noh.

## Girl with a Pearl Earring

1. Edward Snow, *A Study of Vermeer*, rev. ed. (Berkeley: University of California Press, 1994), 3.

2. Quoted in Snow, *A Study of Vermeer,* 2.

3. Martin Pops, *Vermeer: Consciousness and the Chamber of Being* (Ann Arbor, Mich.: UMI Research Press, 1984), 60.

4. Walter A. Liedtke, "Girl with a Red Hat," in Walter A. Liedtke, Michiel C. Plomp, and Axel Rüger, *Vermeer and the Delft School* (New York: Metropolitan Museum of Art, 2001), 386–89.

5. Tracy Chevalier's best-selling novel of 1999 was made into a film in 2003, starring Colin Firth as Vermeer, and Scarlett Johansson as his servant and model, a girl named Griet.

6. Quoted in Frederik J. Duparc and Arthur K. Wheelock Jr., *Johannes Vermeer* (New Haven, Conn.: Yale University Press, 1995), 168.

MARIA TERESA

1. G. K. Chesterton, *The Crimes of England* (New York: John Lane, 1916), 42.

2. Antonio Domínquez Ortiz, Alfonso E. Pérez Sánchez, and Julián Gállego, *Velázquez* (New York: Metropolitan Museum of Art, 1990), 240–43; Madlyn Millner Kahr, *Velázquez: The Art of Painting* (New York: Harper & Row, 1976), 118.

3. Velázquez's other examples include a full-length portrait (with two watches) in the Kunsthistorisches Museum, Vienna; a bust in the Museum of Fine Arts, Boston; and another in the Metropolitan Museum of Art's Robert Lehman Collection; as well as several portraits by his workshop.

4. Stephen E. Marvin, "The Form and the Function of the Mask," in *Heaven Has a Face, So Does Hell: The Art of the Noh Mask* (Warren, Conn.: Floating World Editions, 2010), 76.

5. John W. Nunley and Cary McCarty, *Masks: Faces of Culture* (New York: Abrams, 1999), 228.

MAJA

1. "Maja desnuda (Naked Maja), 1797–1800," in *Goya: Images of Women*, ed. Janis A. Tomlinson (Washington, D.C.: National Gallery of Art, 2002), 228.

2. For the theory that she is Tudó, see Robert Hughes, *Goya* (New York: Knopf, 2003), 241–42. This theory is given dramatic form in Ceferino Palencia's novel *Pepita Tudó* (1901) and in the 1999 film adaptation of Antonio Laretta's 1980 novel *Volavérunt*, starring Penélope Cruz as Tudó and Aitana Sánchez-Gijón as the duchess. The idea that the subject is the Duchess of Alba and a lover of Goya was advanced in the 1958 movie *The Naked Maja*, with Ava Gardner as the titular character, as well as in Samuel Edwards's 1959 novel of the same title.

3. Janis A. Tomlinson, "Goya: Images of Women," in *Goya: Images of Women*, ed. Tomlinson, 17; and Janis A. Tomlinson, "Burn It, Hide It, Flaunt It: Goya's *Majas* and the Censorial Mind," *Art Journal* 50, no. 4 (1991): 59–62.

4. Francisco Calvo Serraller, "Goya's Women in Perspective," in *Goya: Images of Women*, ed. Tomlinson, 26.

5. Tomlinson, "Burn It," 62.

6. For an in-depth discussion of this issue, see Etsuko Terasaki, "Social and Historical Shifts: Changes in Noh Texts," in *Figures of Desire: Wordplay, Spirit Possession, Fantasy, Madness, and Mourning in Japanese Noh Plays* (Ann Arbor: Center for Japanese Studies, University of Michigan, 2002), 7–12; and Edith Sarra, *Fictions of Femininity: Literary Inventions of Gender in Japanese Court Women's Memoirs* (Stanford, Calif.: Stanford University Press, 1999).

7. "Maja desnuda," 230.

8. For the irreality of Noh, see Thorsten Botz-Bornstein, *Aesthetics and Politics of Space in Russia and Japan: A Comparative Philosophical Study* (Lanham, Md.: Lexington Books, 2009), chap. 2, "Space in Noh-Plays and Icons."

MADONNA

1. Quoted in Poul Erik Tøjner, *Munch: In His Own Words* (Munich: Prestel, 2001), 135.

2. See Mary Kay Norseng, *Dagny: Dagny Juel Przybyszewska, the Woman and the Myth* (Seattle: University of Washington Press, 1991); and Shelley Wood Cordulack, *Edvard Munch and the Physiology of Symbolism* (Madison, N.J.: Fairleigh Dickinson University Press, 2002), 21.

3. Quoted in Ragna Stang, *Edvard Munch: The Man and His Art*, trans. Geoffrey Culverwell (New York: Abbeville, 1979), 116.

4. Stang, *Edvard Munch*, 136.

5. Arve Moen, *Edvard Munch: Woman and Eros*, trans. Christopher Norman (Oslo: Forlaget Norsk Kunstreproduksjon, 1957), 26. See also *Edvard Munch: The Frieze of Life* (London: National Gallery Publications, 1992), 72.

6. Stephen E. Marvin, *Heaven Has a Face, So Does Hell: The Art of the Noh Mask* (Warren, Conn.: Floating World Editions, 2010), 80–84.

KISS

1. For the period and its connection with Japan, see William M. Johnston, *Vienna, Vienna: The Golden Age 1815–1914* (New York: C. N. Potter, 1981); Edmund de Waal, *The Hare with Amber Eyes: A Family's Century of Art and Loss* (New York: Farrar, Straus, and Giroux, 2010); and *Wīn no japonisumu* (Japonisme in Vienna) (Tokyo: Tokyo shinbun, 1994).

2. Peter Vergo, *Art in Vienna 1898–1918: Klimt, Kokoschka, Schiele, and Their Contemporaries* (London: Phaidon, 1975), 24.

3. Johnston, *Vienna, Vienna*, 246.

4. Vergo, *Art in Vienna*, 15.

5. Vergo, *Art in Vienna*, 147.

6. For discussion of these masks, see Sherman E. Lee, "Noh: Masks and Robe," *The Bulletin of the Cleveland Museum of Art* 62, no. 2 (1975): 31; and Michishige Udaka, *The Secrets of Noh Masks* (Tokyo: Kodansha, 2010).

JEANNE

1. Linda Lappin, "Missing Person in Montparnasse: The Case of Jeanne Hébuterne," *The Literary Review* 45, no. 4 (2002): 785–811.

2. June Rose, *Modigliani, The Pure Bohemian* (New York: St. Martin's, 1990), 173.

3. Lappin, "Missing Person in Montparnasse," 794–99.

4. Gabriele Crepaldi, *Modern Art 1900–1945: The Age of Avant-Gardes* (New York: Collins Design, 2007), 399.

5. Quoted in Douglas Hall, *Modigliani*, rev. ed. (Oxford: Phaidon, 1984), 150.

ANGELINA

1. For a biography, see Andrew Morton, *Angelina Jolie: An Unauthorized Biography* (New York: St. Martin's, 2010). Jolie writes of her humanitarian experience in *Notes from My Travels: Visits with Refugees in Africa, Cambodia, Pakistan, and Ecuador* (New York: Gallery Books, 2003).

2. Angelina Jolie, "My Medical Choice," *New York Times*, May 14, 2013, A25. The essay, widely hailed for its bravery, was written to educate women who carry the same gene.

3. For the *Semimaru* story, and a translation of the Noh play, see Susan Matisoff, *The Legend of Semimaru, Blind Musician of Japan* (New York: Columbia University Press, 1978).

4. The literal meaning of *hannya* (Sk. *prajñā*) is wisdom. Hannya masks and their meanings are described in Michishige Udaka, *The Secrets of Noh Masks* (Tokyo: Kodansha, 2010), 51–52.

CAT. 11

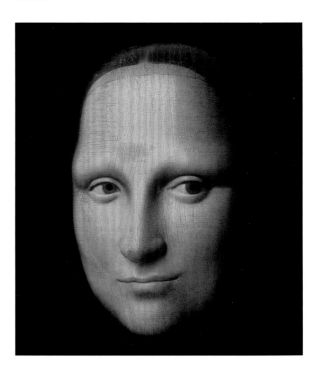

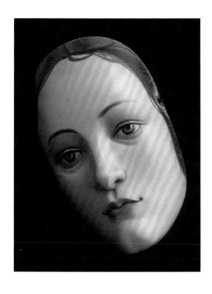
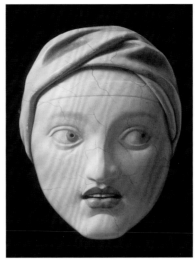
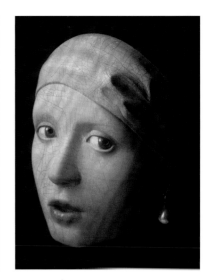
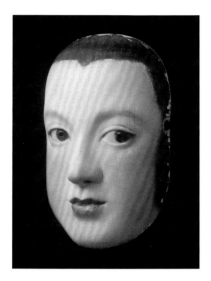
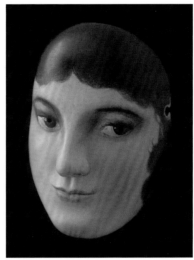
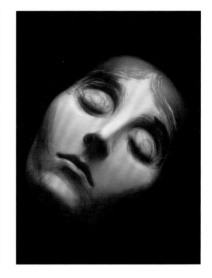
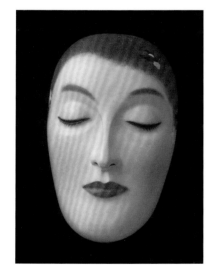
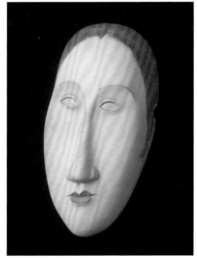
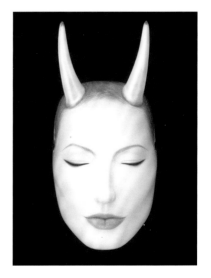

CAT. 12 THROUGH 20

# EPILOGUE

Matthew Welch

# TRADITION TRANSFUSED: SHARAKU'S NOH DEBUT

Matthew Welch

Ironically, it was a trip to the United States in 1991 that first prompted Bidou Yamaguchi—then known as Yamaguchi Hiroki—to become interested in Japanese sculpture. During his visits to the Museum of Fine Arts, Boston, the Cleveland Museum of Art, the Minneapolis Institute of Arts, the Metropolitan Museum of Art, and the Freer Gallery of Art at the Smithsonian, he was particularly affected by the Buddhist sculpture he encountered. A recent graduate of the Kuwasawa Design School in Tokyo, he was impressed by the subtlety of the craftsmanship—especially the refinement of the facial features. Although he had certainly seen Buddhist sculpture in Japan within religious settings, and occasionally in museums, something about unexpectedly viewing these images in a different context piqued his interest.

After returning to Japan, Yamaguchi decided to try his hand at mask carving. While visiting a shop to purchase chisels, he was introduced by the clerk to Ogawa Gendou (b. 1945), who had coincidentally stopped there for supplies. Gendou is a master Noh mask artist affiliated with the school of Living National Treasure Nagasawa Ujiharu (1912–2003). After chatting for a bit, Yamaguchi boldly asked if he could apply for an apprenticeship. Even today, he recalls Gendou's pointed response: "Passion is not enough

in this field, you have to have talent. Show me what you can do first, and then I'll decide if you can apprentice or not."[1] For the next three months Yamaguchi was a frequent visitor to Gendou's studio, where he worked on a mask of Hakushiki-Jō, a kind of divine elder whose felicitous song and dance, known as *Okina* in the Noh repertoire, is believed to bestow blessings on the community for prosperity, long life, and fecundity. As such, the mask was an auspicious choice for the hopeful young artist.

As in all traditional apprenticeships in Japan, pupils learn by observation (*minarai*) rather than by direct instruction. Over the course of his trial period, Yamaguchi learned by silently watching Gendou work. Later, he would try to apply the techniques and processes he had observed to his own work on the Hakushiki-Jō mask. Of the experience, Yamaguchi recalls the exhilaration he felt in discovering an innate skill: "I felt like I was born to carve."[2] Gendou, who would periodically check on the progress of his young charges, was surprised by Yamaguchi's rapid progress and asked repeatedly if he had received some sort of instruction before. In the end, he was so impressed with Yamaguchi's ability that he readily accepted him as an official member of the studio in 1992.

As an apprentice, Yamaguchi continued to follow his master's example. He learned how to take care of his tools, and even how to create his own chisels. To improve his skill and efficiency at carving wood, he performed the initial rough carving for masks that Gendou would finish. In the evenings, after his work in the studio was finished, Yamaguchi devoted himself to his own projects. In this manner, he estimates that he worked on some sixty masks, a core group out of a repertoire of some two hundred. After nearly five years—a comparatively short time—Gendou conferred an art sobriquet on Yamaguchi, a traditional means of recognizing that an apprentice has achieved an appropriate level of skill and knowledge. The name, "Bidou," is a two-character compound consisting of "bi," from the Buddhist guardian deity Bishamonten, and "dou," a character used in Gendou's own art name.

As a carver of Noh masks, Bidou enjoyed some success as a young artist. In 1998 his masks were recognized as acceptable for use by actors associated with the Hōshō school of Noh acting by Hōshō Fusateru (1958–2010), head of the school. In 2002, the grand master himself ordered two masks—Shaka and Chū-Beshimi—from Bidou for a performance of the Noh play *Dai-e* (The Great Sermon). In addition, the art gallery associated with Nihon University acquired fifteen Noh masks by Bidou between 2000 and 2005.

Bidou's career as a traditional Noh mask artist seemed set, and yet he harbored misgivings. The emphasis that Noh placed on precisely replicating past examples of masks, considered impossible to better, was frustrating for the young artist, who began to view his work as mechanical. What is more, the largely codified tradition of Noh restricted the possibilities of the masks he could replicate. He had little hope of examining prized masks owned and used by other schools of Noh, because permission to do so simply would not be granted to an artist not associated with those schools.

Most Japanese would have taken considerable comfort in being accepted into a group. Moreover, the clearly defined parameters of the group would be viewed not as limitations, but as the underpinnings of their identity and the source of a common "language." While Bidou, too, felt a strong sense of belonging to the Ujiharu school and, by extension, the Hōshō lineage of Noh performers, he also felt a certain need to push the boundaries of his profession. It is easy to view his impetuous curiosity and ambition as the result of his relative youth—as something that he might eventually outgrow. However, there is much to suggest that Bidou was predisposed toward thinking about things a

bit differently. On some basic level, his experience at the Kuwasawa Design School undoubtedly ingrained in him the notion of design as a way of thinking, a process, rather than adherence to a predetermined formula or repertoire.

In addition, Bidou's relationship with printmaker and installation artist Yoshida Ayomi (b. 1958), now his wife, has undoubtedly had an impact on his career trajectory. Scion to an entire lineage of woodblock printmakers, Ayomi grew up in an artistic household that respected the creative process and questioned the status quo. In 1899, her paternal grandfather, Yoshida Hiroshi (1876–1950), had bravely boarded a steamship bound for the United States, his luggage laden with his watercolor paintings. Intent on introducing his work to American collectors, he had grown impatient waiting for a government scholarship to go abroad, and so had financed the trip himself.[3] Over the course of his long career, lasting until his death in 1950, Hiroshi also became adept at western-style oil painting and woodblock print design, in addition to watercolors. Ayomi's father, Yoshida Hodaka (1926–1995), was also an artist of considerable note, a vanguard of Japan's burgeoning art scene and among the first wave of artists to champion Abstract Expressionism. He incorporated elements of Primitivism into his work after encountering Mayan artifacts on a trip to Mexico. Later, his work became more closely aligned with the Pop art movement as he appropriated images from media, which he reproduced in collage-like compositions printed in a variety of techniques.[4] In addition to her grandfather and father, Yoshida Ayomi's paternal grandmother Yoshida Fujio (1887–1987); her mother, Yoshida Chizuko (b. 1924); her uncle Yoshida Tōshi (1911–1995); and her aunt Yoshida Kiso (1919–2005) were all artists.

Ayomi has managed to forge a unique identity among her family of artists. More conceptual and process-oriented, her recent installations stray from printmaking— the hallmark of her family—while still strongly referencing this tradition by making use of the wood blocks and chips that result from the process of carving. Like her father and grandfather, Ayomi has established an international reputation with exhibitions, artist-residencies, and site-specific commissions occurring as often abroad as in Japan. She is constantly engaged in a process of self-critique and exploration, and she continues to evolve as an artist.

Given Bidou's training at Kuwasawa Design School, his relationship with Yoshida Ayomi and the Yoshida family, and his curiosity about contemporary art both in Japan and abroad—fostered, in part, by the couple's frequent travels—it seems only natural that he would begin to question the limitations of his tradition-bound field. In the same somewhat heretical manner in which he first began to carve Noh masks, Bidou launched in yet another direction in 2003. He began to fashion three-dimensional "masks" inspired by icons of western art that he had first encountered in art books as a child, and that he sometimes experienced in person as an adult. For the earliest of these "persona" masks, he focused on *Mona Lisa* by Leonardo da Vinci (1452–1519) [cat. 11] and *Birth of Venus* by Sandro Botticelli (c. 1444–1510) [cat. 12]. These masks compel us to reconsider the famous visages by isolating them from the backgrounds of their original paintings. The effect is startling and disarming, confounding long-held expectations and causing us to question, momentarily, our assumptions about "appearance" and "reality." The recontextualization of these visages and their newfound three-dimensionality animates them in ways unexpected to all but Noh devotees. The play of light and shadow

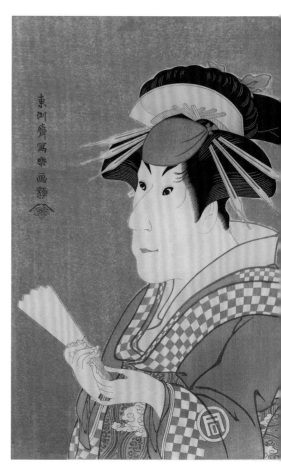

CAT. 21

TŌSHŪSAI SHARAKU

*Sanogawa Ichimatsu III as Onayo, the Prostitute of Gion (Sansei Sanogawa Ichimatsu no Gion hakujin Onayo)*, 1794

Ink and pigment on paper, reprinted by Adachi, 1940

15.38 x 10.25 in.

USC Pacific Asia Museum, Gift of Peter Ries

Cat. 22

Bidou Yamaguchi

*Onayo*, 2013 (after 2007)

Japanese cypress, seashell,
natural pigment, lacquer

8.35 x 5.04 x 3.54 in.

Courtesy of the artist

across facial contours brings subtle shifts in our impression of the subject's mood and temperament—an effect long capitalized upon by Noh actors to convey the changing emotional states of the characters they portray in their masked roles.

At the same time, Bidou remained true to his training and the tradition of reproducing earlier Noh masks with absolute fidelity. In his renditions of *Mona Lisa* and *Venus,* for example, he carefully studied high-resolution photographs of the surfaces of these images and fastidiously reproduced the fine network of hairline cracks in the aged oil paint and layers of varnish. Similarly, he noted the effects of time and exposure, selecting his pigments to mimic the softening of color intensity over time and the amber hues of darkened varnish. The point of this exactitude was not to demonstrate his prodigious skill and astonishing patience. Rather, he realized that part of the mystery and depth (conveyed by the Japanese term *yūgen*) of historical Noh masks derives from the gravitas that comes with age, implicit in the term *sabi* (rust or patina, suggestive of things subdued and worn). Even traditional masks depicting young women possess a numinous quality—induced, in part, by their time-worn appearance. The result is a marvelous interplay between the emergence of these iconic faces from the canvas—as if suddenly brought to corporeal life, and yet locked in time; seemingly alive and yet impossibly aged.

As unexpected as it is to encounter one of these transformed icons, Bidou states that his purpose was never to shock for shock's sake. He is critical of contemporary artists whose output seems to consist of a string of novelties without any underlying point of view. In creating his western "persona" masks, Bidou was curious to see if he could capture the "*yūgen*" that he felt was an integral quality of these works of art. Much has been written on *yūgen* as an aesthetic concept vital to the understanding of Japanese

art, but without equivalence in the West. Moreover, even within Japanese art, the term is used most often in association with poetry and Noh performance. Zeami (1363–1443) himself defined the word in metaphorical terms, likening the concept to transient moments of ineffable beauty. In Noh performance, *yūgen* suggested transcendent elegance and gracefulness. But for Bidou, the notion is much more elastic: "My own idea of *yūgen* definitely ranges beyond the sensibilities and aesthetics of Noh. It was precisely because I did feel that commonality with the original works [of western art that] I was able to create them as masks."[5]

Rendering famous visages from western art caused Bidou to consider Japan's equivalents. Though he was aware of early forays into portraiture—the so-called likeness pictures (*nise-e*) of Jingoji featuring the courtier Fujiwara no Mitsuyoshi (active late twelfth century) and the warriors Minamoto no Yoritomo (1147–1199) and Taira no Shigemori (1138–1179), traditionally attributed to Fujiwara Takanobu (1142–1205)—Bidou ultimately chose to create a series of masks based on the more overtly expressive images of Kabuki actors by the eighteenth-century print designer Tōshūsai Sharaku (active 1794–95). The choice itself might be considered ironic. Kabuki, as it developed in the seventeenth century, was the robust and lowbrow counterpoint to the elegant and stately Noh tradition. Kabuki plays dramatized feats of bravery and acts of heartrending betrayal, culled from past military tales—often with thinly veiled allusions to contemporary government authority and corruption. "Domestic" Kabuki dramas sensationalized recent occurrences, like the love-suicides of star-crossed lovers or the executions of murderers and arsonists. Kabuki's focus on the temporal aspects of humanity is stridently unlike Noh, with its emphasis on the spiritual, transient, and otherworldly.

Noh actors don masks with delicate and refined features (at least those that represent humans or human spirits), thus allowing the actor to convey exquisitely subtle shifts in mood or temperament. With a slight tilt of the head, the actor manipulates the play of light and shadow across the contours of the mask, making the visage appear suddenly hopeful or clouded with despair. Kabuki actors, on the other hand, wear dramatic makeup *(kumadori)* that accentuates their features and, through vivid coloration, symbolically conveys the nature of their characters. Makeup, unlike masks, also allows for exaggerated facial expressions and eye movements.

About the conflation of these two diametrically opposed theatrical traditions and his decision to make masks based on woodblock prints of Kabuki actors in character roles, Bidou reminds us that things are rarely as absolute as they might seem: "Zeami combined many different things to make up the basis of what we know today as Noh, even elements from other theatrical traditions."[6] While it is undoubtedly true that Zeami and his father, Kan'ami (1333–1384), incorporated elements of music and dance from various existing traditions in the fourteenth century to create Noh, Bidou's ecumenical approach is also part and parcel of contemporary art practice. Today, artists place far less emphasis on traditional categories while valuing far-flung knowledge, convergence, deconstruction, appropriation, and recontextualization. As a thoroughly twenty-first-century artist, Bidou is unfettered by the distinctions that have so strongly defined the historical boundaries between Noh and Kabuki.

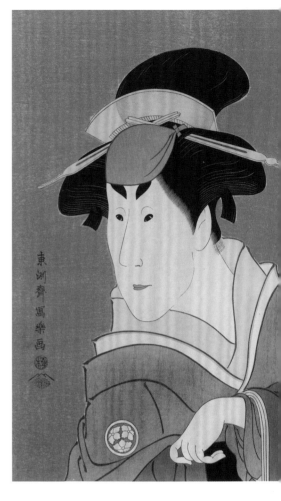

CAT. 23

TŌSHŪSAI SHARAKU

*Osagawa Tsuneyo II as Sakuragi, Ippei's Elder Sister Osan (Nisei Osagawa Tsuneyo no Ippei ane Osan)*, 1794

Ink and pigment on paper, reprinted by Adachi, 1940

15.38 x 10.25 in.

USC Pacific Asia Museum, Gift of Peter Ries

In 2007, Bidou completed his first mask based on a print by Sharaku; it shows the *onnagata*, or female impersonator, Sanogawa Ichimatsu III (1759–1813) as the unlicensed courtesan *(hakujin)* Onayo of Gion in the play *Hana Ayame Bunroku Soga* (Blooming Iris: Soga of the Bunroku Era), performed at the Miyako Theater in Edo in 1794 [cats. 21 and 22]. The play was probably one of the *Kameyama no adauchi mono* (Kameyama revenge plays), which dramatized an actual revenge killing that occurred at Kameyama Castle in 1701. The brothers Ishii Genzō and Ishii Hanzō tracked down and killed Akabori Gengoemon, who had earlier murdered their father, Ishii Uemon. However, since the shogunate prohibited the depiction of sensational or scandalous events that occurred during their rule, such stories were often cast as reenactments of the famous revenge story of the warriors Soga Jūrō and Soga Gorō. In the twelfth century, the Soga brothers avenged their father's death at the hands of his avaricious cousin, Kudō Sukeyasu. The event was immortalized by itinerant storytellers and finally written down in the fifteenth century as the *Soga Monogatari* (Tales of the Soga). Thus, the title of the 1794 production about the Ishii brothers, *Hana Ayame Bunroku Soga*, refers to the Soga brothers. In Bunraku (puppet) and Kabuki dramatizations of both accounts, the brothers visit the pleasure quarters before exacting their revenge. While the precise role of Onayo is not known, she likely represents one of the women the brothers encountered there.

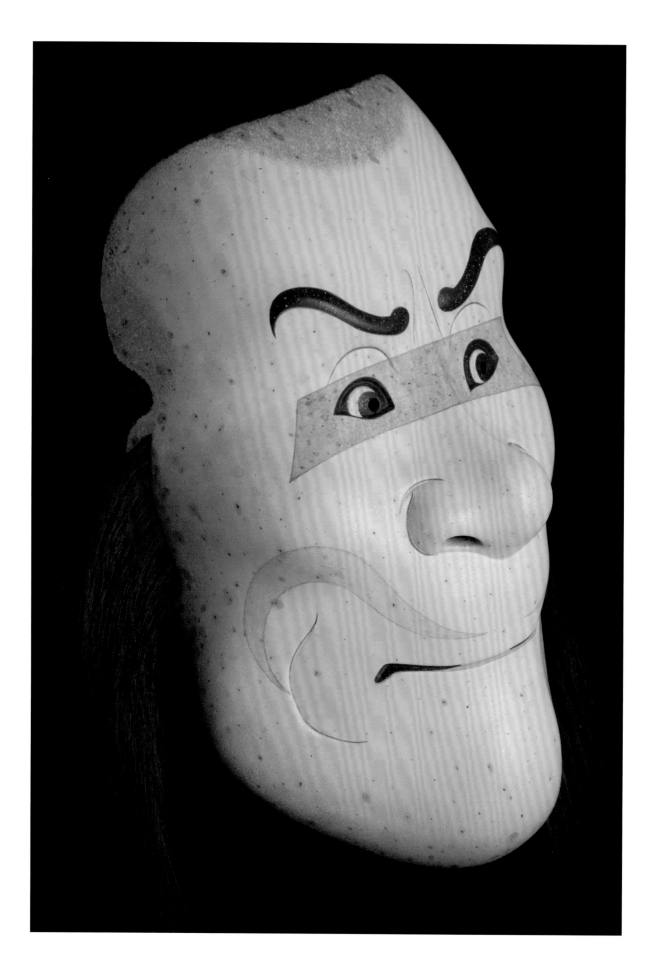

Bidou says he was attracted to the works of Sharaku because of their power and personality: "Sharaku's bust portraits are among the few that can hold their own against western portrait art."[7] Ōkubi-e, or large-scale bust portraits, also addressed his prosaic concerns of rendering a Japanese portrait in mask form when most are so minimally descriptive: "I thought the larger close-ups of ōkubi-e would offer more detail and facial expression to work with—at least I wanted to test that premise."[8] Even so, the characteristic flatness of ukiyo-e portraiture—in which sinuous line work defines shape but does little to suggest texture or volume—presented a distinctly different challenge than his masks after western masterpieces. Chiaroscuro in oil painting had provided a veritable topographic map to the contours of a subject's physiognomy. In carving his Kabuki-inspired masks, Bidou had to surmise the height of cheekbones and brows and the relative depth of eye sockets and cheek hollows, as the original prints provide little information in this regard. In Sharaku's prints—indeed, in ukiyo-e in general—the face is an expanse of white (often the unprinted color of the paper), defined only by outlines. Similarly delicate lines indicate the shape of the nose, lips, and eyes. While this artists' "shorthand" produced visages that were virtually indistinguishable one from the next, Sharaku's close observation, manifest in subtly descriptive facial outlines, makes his portraits instantly identifiable.

Another mask in Bidou's *Kabuki* series reproduces the face of Osagawa Tsuneyo II (1753–1808), a renowned *onnagata*, after a print designed by Sharaku in 1794 [cats. 23 and 24]. While it has been possible to identify the roles of most of the actors depicted by Sharaku in his oeuvre of 144 prints, the image of Tsuneyo is an exception. Since Tsuneyo is known to have performed the role of Ippei's sister in *Koinyōbō Somewake Tazuna* (The Two-Colored Reins) and that of Yoshitsune's lover, Shizuka, in *Yoshitsune Senbon Zakura* in 1794, it is possible that the print might represent one of these roles. However, the costume worn by Tsuneyo in Sharaku's print does not match that worn for either role. It has been suggested that Sharaku's image shows Tsuneyo in *Koinyōbō Somewake Tazuna* as Takemura Sadanoshin's wife, Sakuragi—a role that Tsuneyo did not actually perform, but for which he may have been considered.[9]

In *Koinyōbō Somewake Tazuna,* Takemura Sadanoshin, father of lady-in-waiting Shigenoi, decides to kill himself in order to atone for his daughter's adulterous affair. Sakuragi agonizes over her husband's decision. In Sharaku's print and in Bidou's mask, Sakuragi's sad, wistful eyes, tight mouth, clenched jaw, and knit brow all indicate her tormented psychological state.

For his masks of Sakuragi and Onayo, Bidou carefully reproduced a portion of the *murasaki-bōshi*, the small piece of cloth originally used to cover the shaved forelocks of *onnagata*. Even after actors began to wear elaborate wigs for female roles, they continued to affix the *murasaki-bōshi* to the front of the wig as a sign of deference to the past. The *murasaki-bōshi* in Bidou's masks reminds us that an actor who might don such a mask would also wear an elaborate wig of the type shown in Sharaku's prints. Without the wig, the particularly masculine features—the strong jaw and substantial nose—of female impersonators would appear especially pronounced, and thus heighten the strangely assertive nature of the masks. If actually used in a performance, however, the mass of the wig would serve to balance these facial characteristics.

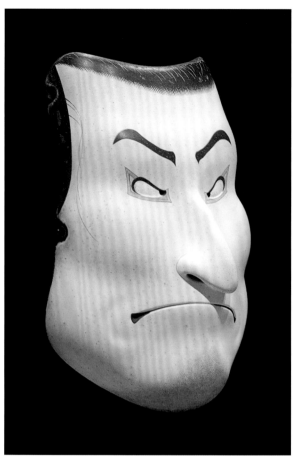

Bidou's foray into Kabuki-inspired masks is not limited to images of *onnagata*. He has also created a mask based on Sharaku's print of the actors Sawamura Yodogorō II as Hōgen and Bandō Zenji as Oni no Sadobō in the Kabuki play *Yoshitsune Senbon Zakura* (Yoshitsune and a Thousand Cherry Trees), performed at the Kawarazaki Theater in Edo in 1794 [cat. 25]. The play is based on the true story of the warrior brothers Yoshitsune and Yoritomo of the Minamoto clan in the twelfth century. After successfully waging a military campaign against the rival Taira clan, Yoritomo turned against Yoshitsune and sent his army to kill him. Yoshitsune evaded his brother's forces for several years by seeking refuge among his allies. During this time, he had to remain on guard for those who might betray him. Bidou created a mask of the character Oni no Sadobō, an evil monk who seeks Yoshitsune's downfall [cat. 26]. In fact, Oni no Sadobō is a stock character in Kabuki plays who is referred to as a *namazu-bozu*, a "catfish monk" who has a shaved head and long side locks that resemble catfish whiskers.

In Sharaku's print, the upstanding character of Kawatsura Hōgen peers apprehensively at Oni no Sadobō and clenches his fist, thus conveying his concern about the motivations of the monk. Oni no Sadobō, on the other hand, looks past Kawatsura, perhaps furtively scanning for signs of the elusive Yoshitsune. His right hand is splayed open, as if in surprise, suggesting that he may have just made an important discovery. Bidou's mask amplifies the feral quality of Sharaku's Oni no Sadobō by giving volume to the character's broad, upturned nose; strong, clenched jaw; thick, arching eyebrows; and tenacious gaze.

CAT. 27

TŌSHŪSAI SHARAKU

*Ōtani Oniji III as the Retainer Edobei (Sansei Ōtani Oniji no yakko Edobei)*, 1794

Ink and pigment on paper, reprinted by Adachi, 1940

15.38 x 10.25 in.

USC Pacific Asia Museum, Gift of Peter Ries

CAT. 28

BIDOU YAMAGUCHI

*Edobei*, 2011

Japanese cypress, seashell, natural pigment, lacquer

8.27 x 5.51 x 3.54 in.

Courtesy of Sebastian Izzard LLC.

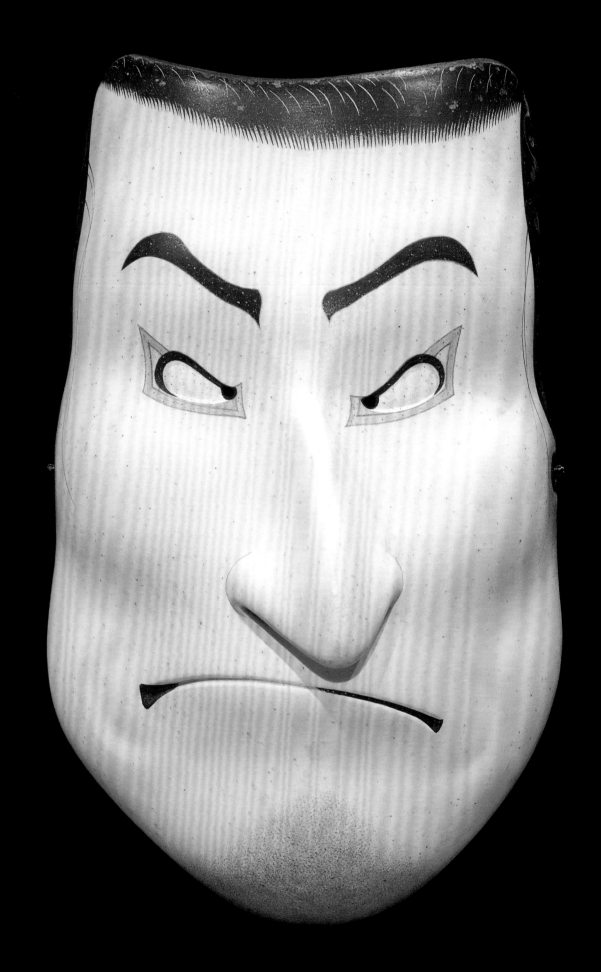

Further contributing to the monk's loutish appearance are his long side locks, incongruous with his religious position and thus further indication of his corrupt nature. In choosing to affix actual hair to the mask, Bidou had ready precedent within the Noh mask lexicon. Masks used to represent male elders and gods, including the divinities of *Okina* song and dance sequences, often have white hair, mustaches, and beards—thus contributing to the impression of extreme age. Horsehair is used rather than human hair because it is stronger and more easily maintained. For Oni no Sadobō's side locks, Bidou used black horsehair.

Another mask created by Bidou also represents a dissolute male character [cat. 28]. It is based on Sharaku's depiction of the actor Ōtani Oniji III in the role of Edobei [cat. 27] in the play *Koinyōbō Somewake Tazuna*, performed at the Kawarazaki Theater in 1794. In the play, Edobei is a villainous thief who leads a band of ruffians. They attack Ippei, the servant of Date no Yosaku, stealing the money he is carrying, which is supposed to be used to pay off the debts of a geisha, a favorite of Yosaku's lord. This act sets into motion a series of tragic events. Sharaku's print captures the moment of confrontation between Edobei and Ippei. Another print by Sharaku depicts Ippei beginning to draw his sword (Sharaku created nine prints inspired by *Koinyōbō Somewake Tazuna*). The image of Edobei, in turn, shows his reaction. Both hands project from his inner robes, as he prepares to cast off his *haori* and fight. His fingers are splayed, conveying his anger and aggression. His mouth is pulled down in an ireful scowl, and his eyes are crossed, a Kabuki convention used to convey extreme emotion—in this case, hateful rage.

Bidou masterfully gives volume to the character's face, endowing him with pronounced cheekbones. Doing so allowed Bidou to produce contrasting hollows for the lower portion of the cheeks. In sculptural form, this creates shadows that accentuate the downward direction of the character's eyes and the thrust of his large nose, further emphasizing the grotesque deformation of his features as he undertakes his terrible crime.

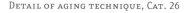

Detail of aging technique, Cat. 26

In a playful concession to the "flatness" of *ukiyo-e* prints, however, Bidou carves his Kabuki masks to reflect the orientation of the original portrait. The facial proportions of such masks are "correct" only when viewed directly from the "front," as reflected in the printed image. If viewed at an oblique angle from the right or left [see alternate photo, cat. 28], the features are accordingly distorted. While doing so would seem to negate the effect of rendering a two-dimensional image in sculptural form, in fact it transparently calls attention to the artifice of the idiom—a decidedly contemporary approach.

David Elliott has observed about contemporary art in Japan that "historic modes of expression have been reframed by artists who feel free to move in and out of their respective conventions and contexts...this legacy is often the starting point for critical or subversive images that question conventional ways of seeing and thinking."[10] As a fully informed and critical thinker, Noh mask artist Bidou Yamaguchi has indeed reframed elements of historical artistic expression in Japan, and his masks challenge long-held assumptions. His intent, however, is not subversive. The last thing he hopes to achieve by appropriating imagery from one tradition (Kabuki), for use in another (Noh), is controversy or notoriety. Rather, he wants to apply an artistic idiom, one in which he is innately skilled, to a broader range of portraiture. Will the results still possess the enigmatic, sometimes numinous, qualities of the originals? For Bidou, heresy does not dwell in the creative motivations of artists but rather in the forces that would doom Japan's brilliant artistic traditions to a moribund and bloodless inertia. Though his new masks may be unexpected, he intends that they be squarely part of the Noh tradition— not separate from it. And while he appreciates the recent attention his masks have received in exhibitions in the United States, like all Noh mask makers, he longs for the day when they will be animated by actual use on stage. Only then, he contends, will he know if he has been truly successful.

# NOTES

1. E-mail correspondence with Bidou, August 1, 2013.

2. E-mail correspondence with Bidou, August 1, 2013.

3. Yasunaga Koichi, "Lofty Mountains and Misty Valleys: The Art and Life of Yoshida Hiroshi," in *A Japanese Legacy: Four Generations of Yoshida Family Artists* (Minneapolis: The Minneapolis Institute of Arts, 2002), 27.

4. Eugene M. Skibbe, "Yoshida Hodaka: Magic, Artifact, and Art," in *A Japanese Legacy*, 110–19.

5. E-mail correspondence with Bidou, July 17, 2013.

6. E-mail correspondence with Bidou, July 12, 2013.

7. E-mail correspondence with Bidou, July 12, 2013.

8. E-mail correspondence with Bidou, July 12, 2013.

9. Yuiko Kimura-Tilford, entry for cat. 113, in *Worldly Pleasures, Earthly Delights: Japanese Prints from the Minneapolis Institute of Arts* (Minneapolis: The Minneapolis Institute of Arts, 2011), 148.

10. David Elliott, "Bye Bye Kitty...," in *Bye Bye Kitty!!! Between Heaven and Hell in Contemporary Japanese Art* (New York: Japan Society; New Haven, Conn.: Yale University Press, 2011), 8.

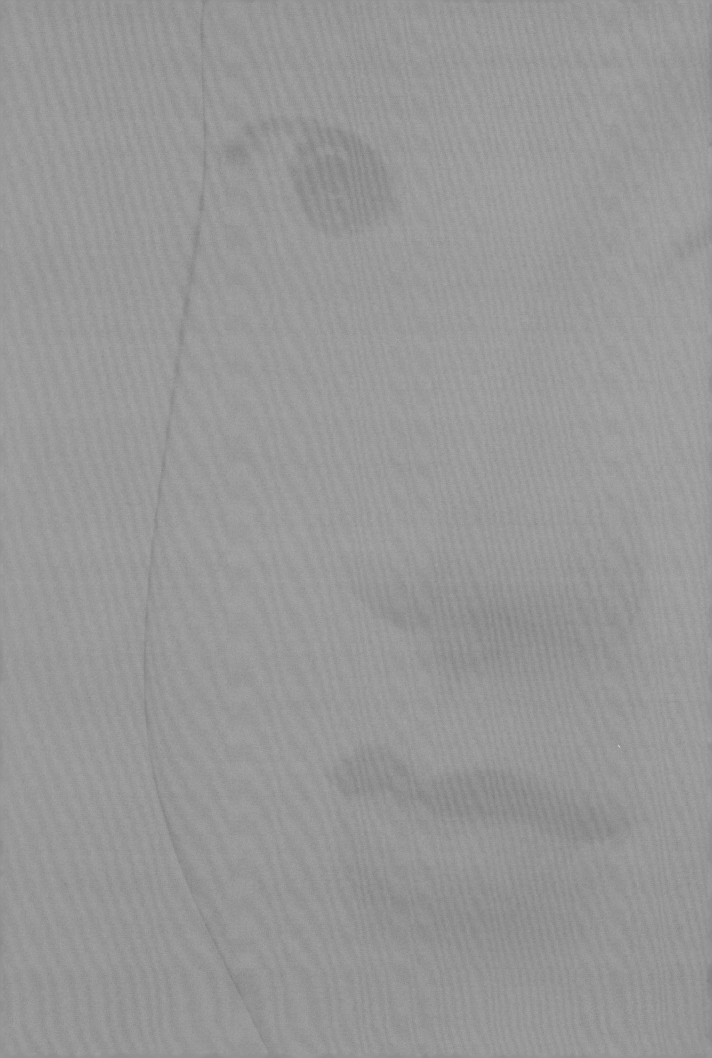

# SELECT BIBLIOGRAPHY AND CHECKLIST OF THE EXHIBITION

# SELECT BIBLIOGRAPHY

Atkins, Paul S. *Revealed Identity: The Noh Plays of Komparu Zenchiku.* Ann Arbor: Center for Japanese Studies, University of Michigan, 2006.

Barthes, Roland. *The Responsibility of Forms: Critical Essays on Music, Art, and Representation.* New York: Hill and Wang, 1985.

Botz-Bornstein, Thorsten. *Aesthetics and Politics of Space in Russia and Japan: A Comparative Philosophical Study.* Lanham, Md.: Lexington Books, 2009.

Brilliant, Richard. *Portraiture.* Cambridge, Mass.: Harvard University Press, 1991.

Brown, Steven T. *Theatricalities of Power: The Cultural Politics of Noh.* Stanford, Calif.: Stanford University Press, 2001.

Camille, Michael. "Simulacrum." In *Critical Terms for Art History,* edited by Robert S. Nelson and Richard Schiff. Chicago: University of Chicago Press, 1996.

Campbell, Lorne. *Renaissance Portraits: European Portrait-Painting in the 14th, 15th, and 16th Centuries.* New Haven, Conn.: Yale University Press, 1990.

Carleton College Art Gallery, ed. *The Art of Sight, Sound and Heart: Visualizing Japanese Theater.* Exhibition catalogue. Northfield, MN: Carleton College, 2011.

Coldiron, Margaret. *Trance and Transformation of the Actor in Japanese Noh and Balinese Masked Dance-Drama.* Lewiston, N.Y.: Edwin Mellen Press, 2004.

Dutton, Dennis. *The Art Instinct: Beauty, Pleasure, and Human Evolution.* New York: Bloomsbury Press, 2009.

Eisenstadt, S. N. *Japanese Civilization: A Comparative View.* Chicago: University of Chicago Press, 1996.

Elliott, David. *Bye Bye Kitty!!! Between Heaven and Hell in Contemporary Japanese Art.* New York: Japan Society, 2011.

Enchi, Fumiko. *Masks.* Translated by Juliet Winters Carpenter. New York: Knopf, 1983; first published in Japanese as *Onna-men,* 1958.

Esterly, David. *The Lost Carving: A Journey to the Heart of Making.* New York: Viking, 2012.

Hare, Thomas. *Zeami's Style: The Noh Plays of Zeami Motokiyo.* Stanford, Calif.: Stanford University Press, 1986.

Hisamatsu, Shin'ichi. *Zen and the Fine Arts.* Translated by Gishin Tokiwa. Tokyo: Kodansha International, 1971; first published in Japanese in 1958.

Inouye, Charles Shiro. *Evanescence and Form: An Introduction to Japanese Culture.* New York: Palgrave Macmillan, 2008.

Ito, Masanobu, ed. *Sharaku Interpreted by Japan's Contemporary Artists.* Exhibition catalogue. Tokyo: Tokyo National Museum, 2009.

Julius, Anthony. *Transgressions: The Offences of Art.* London: Thames & Hudson, 2002.

Klein, John. "The Mask as Image and Strategy." In *The Mirror & the Mask: Portraiture in the Age of Picasso,* edited by Paloma Alarcó and Malcolm Warner. New Haven, Conn.: Yale University Press, 2007.

Kodama, Shōkō. *The Complete Guide to Traditional Japanese Performing Arts.* Tokyo: Kodansha/Bilingual Books, 2000.

Komparu, Kunio. *The Noh Theater: Principles and Perspectives.* Translated by Jane Corddry and Stephen Comee. New York: Weatherhill/Tankosha, 1983.

Looser, Thomas D. *Visioning Eternity: Aesthetics, Politics, and History in the Early Modern Noh Theater.* Ithaca, N.Y.: East Asia Program, Cornell University, 2008.

Lyons, Michael J. , et al. "The Noh Mask Effect: Vertical Viewpoint Dependence of Facial Expression Perception." *Proceedings of the Royal Society B: Biological Sciences* 267, no. 1459 (November 22, 2000): 2239–45.

Mack, John, ed. *Masks and the Art of Expression.* New York: Abrams, 1994.

Marvin, Stephen E. *Heaven Has a Face, So Does Hell: The Art of the Noh Mask.* Warren, Conn.: Floating World Editions, 2010.

McMullen, Roy. *Mona Lisa: The Picture and the Myth.* New York: Da Capo Press, 1977.

Minneapolis Institute of Arts, ed. *A Japanese Legacy: Four Generations of Yoshida Family Artists.* Exhibition catalogue. Minneapolis: Minneapolis Institute of Arts, 2002.

Nearman, Mark. "Behind the Mask of Nō." In *Nō/Kyōgen Masks and Performance: Essays and Interviews,* edited by Rebecca Teele, 20–64. Special issue of *Mime Journal.* Claremont, Calif.: Pomona College Theater Dept. for the Claremont Colleges, 1984.

Nelson, Robert. "Appropriation." In *Critical Terms for Art History,* edited by Robert S. Nelson and Richard Schiff. Chicago: University of Chicago Press, 1996.

Nishimura, Jeanne. "A Life-Giving Art: Traditional Art of Nō Mask Carving." In *Nō/Kyōgen Masks and Performance*: *Essays and Interviews,* edited by Rebecca Teele, 140–47. Special issue of *Mime Journal.* Claremont, Calif.: Pomona College Theater Dept. for the Claremont Colleges, 1984.

Nunley, John W., and Cary McCarty. *Masks: Faces of Culture.* New York: Abrams, 1999.

Payne, Rachel M. "Noh Masks on Stage and in Museums: Approaches to the Contextualization and Conservation of the Pitt Rivers Museum Nō Mask Collection." In *Making Japanese Heritage*, edited by Rupert A. Cox and Christoph Brumann, 78–91. London: Routledge, 2010.

Rath, Eric C. *The Ethos of Noh: Actors and Their Art.* Cambridge, Mass.: Harvard University Asia Center, 2004.

Ribettes, Jean-Michel, and Miura Atsushi. *Les 100 Sourires de Mona Lisa.* Exhibition catalogue. Tokyo: Nihon keizai shinbun, 2000.

Rimer, J. Thomas. *Modern Japanese Fiction and Its Traditions: An Introduction.* Princeton, N.J.: Princeton University Press, 1978.

Sarra, Edith. *Fictions of Femininity: Literary Inventions of Gender in Japanese Court Women's Memoirs.* Stanford, Calif.: Stanford University Press, 1999.

Satō, Dōshin. *Modern Japanese Art and the Meiji State: The Politics of Beauty.* Translated by Hiroshi Nara. Los Angeles: Getty Research Institute, 2011.

Schaap, Robert, and J. Thomas Rimer. *The Beauty of Silence: Japanese Nō & Nature Prints by Tsukioka Kōgyo, 1869-1927.* Leiden and Boston: Hotei Publishing, 2010.

Sekine, Masaru. *Yeats and the Noh.* London: Christopher Murray, 1990.

Sheppard, William Anthony. *Revealing Masks: Exotic Influences and Ritualized Performance in Modernist Music Theater.* Berkeley: University of California Press, 2001.

Shiner, Larry. *The Invention of Art: A Cultural History.* Chicago: University of Chicago Press, 2001.

Starling, Simon. *Project for a Masquerade (Hiroshima).* Hiroshima: Hiroshima City Museum of Contemporary Art, 2011.

Steiner, Wendy. *Venus in Exile: The Rejection of Beauty in Twentieth-Century Art.* Chicago: University of Chicago Press, 2001.

Takeda, Sharon Sadako, ed. *Miracles & Mischief: Noh and Kyōgen Theater in Japan.* Exhibition catalogue. Los Angeles: Los Angeles County Museum of Art, 2002.

Tazawa, Hiroshi, ed. *Sharaku.* Exhibition catalogue. Tokyo: Tokyo National Museum, 2011.

Teele, Rebecca, ed. *Nō/Kyōgen Masks and Performance Essays and Interviews.* In special issue of *Mime Journal.* Claremont, Calif.: Pomona College Theater Dept. for the Claremont Colleges, 1984.

Terasaki, Etsuko. *Figures of Desire: Wordplay, Spirit Possession, Fantasy, Madness, and Mourning in Japanese Noh Plays.* Ann Arbor: Center for Japanese Studies, University of Michigan, 2002.

Tyler, Royall. "'The Path of My Mountain': Buddhism in Nō."
In *Flowing Traces: Buddhism in the Literary and Visual
Arts of Japan,* edited by James H. Sanford, William
R. LaFleur, and Masatoshi Nagatomi. Princeton, N.J.:
Princeton University Press, 1992.

Udaka, Michishige. *The Secrets of Noh Masks.* Tokyo:
Kodansha, 2010.

Vollmann, William T. *Kissing the Mask: Beauty,
Understatement, and Femininity in Japanese Noh
Theater: With Some Thoughts on Muses (Especially
Helga Testorf), Transgender Women, Kabuki Goddesses,
Porn Queens, Poets, Housewives, Makeup Artists,
Geishas, Valkyries, and Venus Figurines.* New York:
Ecco, 2010.

Zeami, Motokiyo. *Kadensho [Fushi kaden].* Translated
by Chuichi Sakurai, Shuseki Hayashi [Lindley
Williams Hubbell], Rokurō Satoi, and Bin Miyai.
Kyoto: Sumiya-Shinobe Publishing Institute, 1968.

———. *On the Art of Nō Drama: The Major Treatises of Zeami.*
Translated by J. Thomas Rimer and Yamazaki
Masakazu. Princeton Library of Asian Translations.
Princeton, N.J.: Princeton University Press, 1984.

# Checklist of the Exhibition

Cat. 1
*Noh Mask: Jido (Young Male Sprite),* 17th century
Wood and polychrome
5.5 x 8 x 3 in.
Gift of Lynda Resnick (M.2007.176)
Los Angeles County Museum of Art, Los Angeles,
California, U.S.A.

Cat. 2
Tsukioka Kōgyo
*Pictures of Noh Plays: Masks (Nōgaku zue),* 1902
Ink and pigment on paper
8.88 x 12.94 in.
Gift of Mrs. Frederick S. Bailey
Collection of Scripps College, Claremont, CA

Cat. 3
Tsukioka Kōgyo
*Pictures of Noh Plays: Picture of Noh Stage
(Nōgaku zue: Nōbutai zu),* 1898
Ink and pigment on paper
9.06 x 13.94 in.
Gift of Miss Lilian Miller
Collection of Scripps College, Claremont, CA

Cat. 4
Tsukioka Kōgyo
*One Hundred Noh Plays: Okina
(Nōgaku hyakuban: Okina shiki),* 1923
Ink and pigment on paper
10.13 x 15 in.
The Aoki Endowment for Japanese Arts and Cultures
Collection of Scripps College, Claremont, CA

Cat. 5
Tsukioka Kōgyo
*One Hundred Noh Plays: The Drunken Imp
(Nōgaku hyakuban: Shōjō),* 1925-1928
Ink and pigment on paper
15 x 10.13 in.
The Aoki Endowment for Japanese Arts and Cultures
Collection of Scripps College, Claremont, CA

Cat. 6
Bidou Yamaguchi
*Shōjō (Drunken Imp),* 2003
Japanese cypress, seashell, natural pigment, lacquer
8.11 x 5.39 x 2.76 in.
Collection of Target Corporation

Cat. 7
Tsukioka Kōgyo
*One Hundred Noh Plays: Birds of Sorrow*
*(Nōgaku hyakuban: Utō)*, 1925-1928
Ink and pigment on paper
15 x 10.13 in.
The Aoki Endowment for Japanese Arts and Cultures
Collection of Scripps College, Claremont, CA

Cat. 8
Bidou Yamaguchi
*Yase-otoko (Emaciated Man)*, 2003
Japanese cypress, seashell, natural pigment, lacquer
9.25 x 5.98 x 3.27 in.
Collection of Kelly Sutherlin McLeod and Steve McLeod

Cat. 9
Tsukioka Kōgyo
*One Hundred Noh Plays: The Feather Mantle*
*(Nōgaku hyakuban: Hagoromo)*, 1925-1928
Ink and pigment on paper
15 x 10.13 in.
The Aoki Endowment for Japanese Arts and Cultures
Collection of Scripps College, Claremont, CA

Cat. 10
Bidou Yamaguchi
*Zō-onna (Middle-Age Woman)*, 1998
Japanese cypress, seashell, natural pigment, lacquer
8.27 x 5.31 x 2.76 in.
Collection of Kelly Sutherlin McLeod and Steve McLeod

Cat. 11
Bidou Yamaguchi
*Mona Lisa*, 2003
Japanese cypress, seashell, natural pigment, lacquer
8.35 x 5.75 x 3.15 in.
Collection of Kelly Sutherlin McLeod and Steve McLeod

Cat. 12
Bidou Yamaguchi
*Venus*, 2004
Japanese cypress, seashell, natural pigment, lacquer
8.5 x 5.24 x 3.03 in.
Courtesy of the artist

Cat. 13
Bidou Yamaguchi
*Delphic Sibyl*, 2007
Japanese cypress, seashell, natural pigment, lacquer
8.46 x 6.69 x 3.66 in.
Courtesy of the artist

Cat. 14
Bidou Yamaguchi
*Girl with a Pearl Earring*, 2005
Japanese cypress, seashell, natural pigment, lacquer
7.87 x 6.65 x 4.52 in.
Collection of Kelly Sutherlin McLeod and Steve McLeod

Cat. 15
Bidou Yamaguchi
*Maria Teresa*, 2013 (after 2006)
Japanese cypress, seashell, natural pigment, lacquer
7.48 x 4.88 x 3.07 in.
Courtesy of the artist

Cat. 16
Bidou Yamaguchi
*Maja*, 2006
Japanese cypress, seashell, natural pigment, lacquer
8.31 x 5.67 x 3.62 in.
Courtesy of the artist

Cat. 17
Bidou Yamaguchi
*Madonna*, 2006
Japanese cypress, seashell, natural pigment, lacquer
8.15 x 5.94 x 3.78 in.
Collection of Kelly Sutherlin McLeod and Steve McLeod

Cat. 18
Bidou Yamaguchi
*Kiss*, 2007
Japanese cypress, seashell, natural pigment, lacquer
8.27 x 5.35 x 3.11 in.
Collection of Kelly Sutherlin McLeod and Steve McLeod

Cat. 19
Bidou Yamaguchi
*Jeanne*, 2006
Japanese cypress, seashell, natural pigment, lacquer
9.21 x 4.92 x 2.87 in.
Collection of Kelly Sutherlin McLeod and Steve McLeod

Cat. 20
Bidou Yamaguchi
*Angelina*, 2007
Japanese cypress, seashell, natural pigment, lacquer
10.83 x 5.35 x 3.62 in.
Courtesy of the artist

Cat. 21
Tōshūsai Sharaku
*Sanogawa Ichimatsu III as Onayo, the Prostitute of Gion*
*(Sansei Sanogawa Ichimatsu no Gion hakujin Onayo)*, 1794
Ink and pigment on paper, reprinted by Adachi, 1940
15.38 x 10.25 in.
USC Pacific Asia Museum, Gift of Peter Ries

Cat. 22
Bidou Yamaguchi
*Onayo*, 2013 (after 2007)
Japanese cypress, seashell, natural pigment, lacquer
8.35 x 5.04 x 3.54 in.
Courtesy of the artist

Cat. 23
Tōshūsai Sharaku
*Osagawa Tsuneyo II as Sakuragi, Ippei's Elder Sister Osan*
*(Nisei Osagawa Tsuneyo no Ippei ane Osan)*, 1794
Ink and pigment on paper, reprinted by Adachi, 1940
15.38 x 10.25 in.
USC Pacific Asia Museum, Gift of Peter Ries

Cat. 24
Bidou Yamaguchi
*Ippei's Sister, Osan*, 2011
Japanese cypress, seashell, natural pigment, lacquer
8.27 x 5.12 x 3.54 in.
Courtesy of Sebastian Izzard LLC.

Cat. 25
Tōshūsai Sharaku
*Sawamura Yodogorō as Kawatsura Hōgen and Bandō Zenji*
*as Oni Sadobō*
*(Nisei Sawamura Yodogorō no Kawatsura Hōgen to Bandō*
*Zenji no Oni Sadobō)*, 1794
Ink and pigment on paper, reprinted by Adachi, 1940
15.38 x 10.25 in.
USC Pacific Asia Museum, Gift of Peter Ries

Cat. 26
Bidou Yamaguchi
*Oni Sadobō*, 2011
Japanese cypress, seashell, natural pigment, lacquer
8.27 x 5.51 x 3.54 in.
Courtesy of Sebastian Izzard LLC.

Cat. 27
Tōshūsai Sharaku
*Ōtani Oniji III as the Retainer Edobei*
*(Sansei Ōtani Oniji no yakko Edobei)*, 1794
Ink and pigment on paper, reprinted by Adachi, 1940
15.38 x 10.25 in.
USC Pacific Asia Museum, Gift of Peter Ries

Cat. 28
Bidou Yamaguchi
*Edobei*, 2011
Japanese cypress, seashell, natural pigment, lacquer
8.27 x 5.51 x 3.54 in.
Courtesy of Sebastian Izzard LLC.

Bidou's seal, burned inside each mask, is the Sanskrit syllable
*vai*. It begins the name of the Buddhist guardian Vaiśrāvaṇa
(Jp. Bishamonten), from which comes the syllable *bi* of Bidou's
name.

# Image Credits

*Traditions Transfigured: The Noh Masks of Bidou Yamaguchi* was organized in conjunction with the University Art Museum by the Museum Studies Program at California State University, Long Beach under the supervision of interim director Prof. Kendall H. Brown.

**Copy edited by** Jean Patterson Davis

**Designed by** Margaret Black

**Printed by** ColorNet Press, Los Angeles, California

The text type used in the book is Whitney, designed by Tobias Frere-Jones.
The headlines and captions are set in Eureka, designed by Peter Bil'ak.

This publication is dedicated to Karin Higa (1966-2013), a sensitive curator, supportive colleague, and introspective spirit.